George Bellows

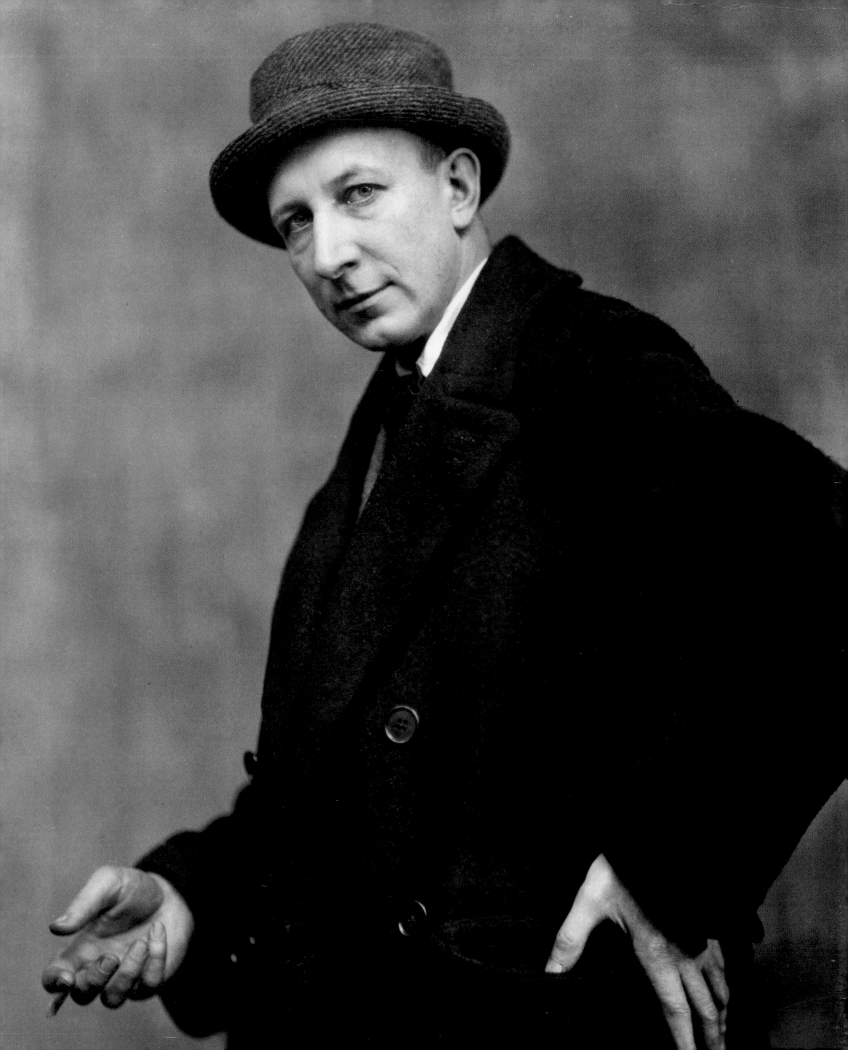

George Bellows
An Artist in Action

Mary Sayre Haverstock

Columbus Museum of Art

MERRELL
LONDON · NEW YORK

First published in 2007 by
Merrell Publishers Limited

Head office
81 Southwark Street
London SE1 0HX

New York office
49 West 24th Street, 8th Floor
New York, NY 10010

merrellpublishers.com

in association with

Columbus Museum of Art
480 East Broad Street
Columbus, OH 43215

columbusmuseum.org

Text copyright © 2007
 Mary Sayre Haverstock
Design and layout copyright
 © 2007 Merrell Publishers
 Limited
Illustrations copyright © 2007
 the copyright holders; see
 captions

British Library Cataloguing-in-
Publication Data:
Haverstock, Mary Sayre
George Bellows : an artist in
action
1. Bellows, George, 1882–1925
– Criticism and interpretation
I. Title II. Columbus Museum of
Art
759.1′3

ISBN-13: 978-1-8589-4393-0
ISBN-10: 1-8589-4393-0

Produced by Merrell Publishers
 Limited
Designed by James Alexander
 at Jade Design
Copy-edited by Matthew Taylor
Proof-read by Barbara Roby
Indexed by Vanessa Bird

Printed and bound in China

Frontispiece
Nickolas Muray
American, born Hungary,
1892–1965
George Wesley Bellows
Circa 1923
Gelatin negative on
nitrocellulose film
10 × 8 in.
(25.4 × 20.3 cm)
Courtesy George Eastman
House, Rochester, New York:
Gift of the Muray Family.
77:0189:0235
Photograph: Nickolas Muray
© Nickolas Muray Photo
Archives

Front cover
Stag at Sharkey's
(detail)
1909
See page 52

Back cover
Mrs. Albert M. Miller
(or White Dress)
(detail)
1913
See page 81

Page 6
Snow dumpers **(detail)**
1911
See page 76

All pictures are by George
Wesley Bellows unless
otherwise stated.

Contents

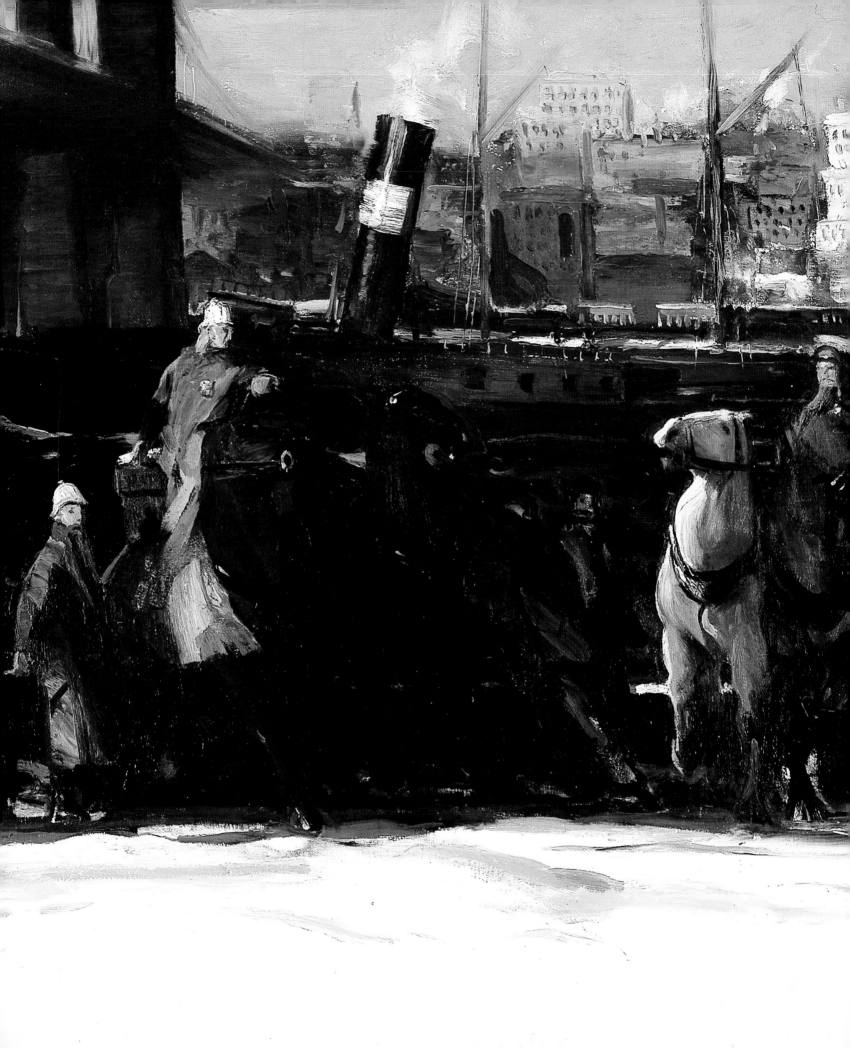

Foreword

GEORGE BELLOWS the artist belongs to the world. His rise from an unknown painter seeking his fortune in New York City to a well-known artist was meteoric. Only months after his arrival in the city and the beginning of his association with Robert Henri, Bellows painted *Central Park* (see p. 30). The following year came *River Rats* (see p. 31), and his first boxing picture was only a year later. Within the incredibly brief span of five years, Bellows had painted his signature work, *Stag at Sharkey's* (see p. 52), been elected one of the youngest associate members of the National Academy of Design, and had received several important portrait commissions. From every perspective, he had become a successful, indeed famous, artist, one recognized worldwide.

If George Bellows the artist belongs to the world, Columbus, Ohio, may lay claim upon George Bellows the man. Bellows's early years in the Buckeye capital in large part shaped the man that he became. His father had an enormous impact on the future painter, as did his mother, his Aunt Fanny, his teachers, his neighborhood, and his friends. If his Rich Street home was not in cosmopolitan New York City, neither was it a sod house on the prairie. The young Bellows was exposed to literature and music, and he most certainly found art in his hometown—and at a tender age. With the determination of his forebears, George Bellows early on decided to become an artist.

By all accounts, Bellows was a "regular guy." He was devoted to his wife and his family. He managed his business well, and he was always interested in learning something new. He was an athlete, a very successful one who was able to supplement a "starving artist's" meager earnings with dollars earned on the baseball diamond. Politically, he certainly was far to the left of where his conservative father stood. Where he truly differed from an engineer or teacher or businessman—perhaps from the man that his father wished him to become—was in his artistic talent and his insatiable drive to become a successful artist.

Bellows never abandoned his hometown. While the Christmas following his arrival in New York was spent with his future wife's family, the following December found him in Columbus, where he painted *Portrait of My Father* (see p. 33). Thereafter, he returned often and kept up friendships forged in childhood. A number of his works feature Columbus subjects, and, in 1911, he sold *Polo at Lakewood* (see pp. 60–61) to the Columbus Museum of Art —the first of many of his works to come here.

The Columbus Art Association, forerunner of the Columbus Museum of Art, asked the native son to arrange an independent show for his hometown. Early in 1911, Bellows, together with Robert Henri, assembled an exhibition that prominently featured the artists known as "The Eight" (George Luks, Everett Shinn, William J. Glackens, John Sloan, Ernest Lawson, Arthur B. Davies, Maurice Prendergast, and Henri) along with, of course, George Bellows. The works were bold, startling, even upsetting to some in the community. Several, but one in particular, fomented local criticism: while nudity, especially male nudes in a work by Rockwell Kent, caused a stir, *The Knock Out* (see p. 38), a boxing picture by Bellows, also upset Columbus's city fathers. The nudes could be and were set aside in a gallery reserved "for gentlemen only," thereby sparing the capital city's fairer sex the shock of confronting the naked form. But boxing was another problem. Pugilism was illegal in Columbus, and the city fathers apparently abhorred any depiction of the sport. The picture was not displayed. While some derided Columbus's provincialism, the fact remains that Bellows's hometown was one of the very early venues for an Ashcan school exhibition outside of New York. And Bellows seemed not too upset about *The Knock Out*.

Bellows continued to return regularly to Columbus for the remainder of his too-brief life. He maintained friendships, visited relatives, sadly attended funerals, and used city scenes for subjects, especially of lithographs. He also secured portrait commissions. And in his hometown, such institutions as this museum and Ohio State University, as well as individuals, continued to collect his works. Today, the Columbus Museum of Art holds the most significant collection of George Bellows's work. He was truly a favorite son.

We at the Museum have long felt the need for a biography of George Bellows, one that looked at him in a more holistic manner than previous art-historical publications have done. We sought a book that was well illustrated, not only with his works but also with photographs of the artist in his surroundings, a book that used vignettes to tell the story behind the art.

We were most fortunate that Mary Sayre Haverstock immediately agreed to undertake the project. Mary provided a wonderful text, and we thank her for all of her efforts. We also thank Jennifer Wilkinson, Curatorial Assistant at the Museum, who tracked down images, arranged photography, assembled credits, and accomplished myriad other tasks with efficiency and a ready smile.

Mark Cole, formerly our colleague in Columbus and now with Cleveland Museum of Art, graciously provided numerous thoughtful comments on the manuscript.

We thank Jim Keny, co-owner of Keny Galleries, and Darlene Cobb, his assistant, for all of their help. Glenn Peck, who is preparing the definitive catalogue raisonné of Bellows, which we await with enthusiasm, was generous with time and advice. David R. Barker of the Ohio Historical Society and Ali Elai of Camerarts in New York City provided original photography, sometimes under trying circumstances. For permission to quote from the memoirs of their late grandmother Harriet Rhoads Kirkpatrick, we thank Sarah Kriska and her brother Peter Diehl. Director of Collections at Muskegon Museum of Art, E. Jane Connell, cheerfully provided documentation pertaining to Bellows's *Baseball Game*. We thank Louis V. Adrean, Associate Librarian, Ingalls Library, Cleveland Museum of Art, and the entire reference staffs of both the Columbus Metropolitan and the Oberlin College libraries for services beyond the call of duty. We called upon Jay Cantor for advice several times, and he was most gracious and helpful.

Many individuals and organizations were most generous in allowing us to reproduce their artworks in this book. We thank Addison Gallery of American Art, Andover; Albright-Knox Art Gallery, New York; Amherst College Library, Archives and Special Collections; Amon Carter Museum, Fort Worth; The Art Institute of Chicago; Art Resource, Scala, New York; Laurie Booth; Brooklyn Museum; Butler Institute of American Art, Youngstown; Carnegie Museum of Art, Pittsburg; Chrysler Museum of Art, Norfolk; Cleveland Museum of Art; *The Columbus Dispatch*; Corcoran Gallery of Art, Washington, D.C.; Ronald H. Cordover; Debra Force Fine Art, Inc., New York; Des Moines Art Center; The Detroit Institute of Arts; Franklin Riehlman Fine Art/Ronald J. Koshes, M.D., New York; George Eastman House, Rochester; Hirschl & Adler Galleries, Inc., New York; Carol Irish; Sarah Kriska; Los Angeles County Museum of Art; Michael and Marilyn Mennello; The Metropolitan Museum of Art, New York; Michael Altman Fine Art and Kate Lester; Michigan State University Libraries, Special Collections, East Lansing; Milwaukee Art Museum; Montclair Art Museum; Mimi Muray Levitt; Museum of Fine Arts, Boston; Museum of Fine Arts, Springfield; Muskegon Museum of Art; National Academy Museum, New York; National Gallery of Art,

Washington, D.C.; University of Nebraska-Lincoln; The Nelson-Atkins Museum of Art, Kansas City; New Britain Museum of American Art; The Ohio State University Alumni Association, Kelly Jurich and Lynn Bonenberger; The Ohio State University Libraries, Columbus; The Ohio State University Faculty Club, Columbus, Jeff White; The Ohio State University Photo Archives, Columbus; Glenn Peck; Pennsylvania Academy of the Fine Arts, Philadelphia; Rhode Island School of Design Museum of Art, Providence; Samuel Dorsky Museum of Art, State University of New York at New Paltz; San Diego Museum of Art; Don Shackelford; Sheldon Memorial Art Gallery, Lincoln; The Smithsonian American Art Museum, Washington, D.C.; Sotheby's, New York; Toledo Museum of Art; Whitney Museum of American Art, New York; Erving and Joyce Wolf; Worcester Art Museum; and Yale University Art Gallery, New Haven.

For the invaluable assistance, advice, and support she has given over the years to Bellows's biographers and custodians of his works, we thank Laurie Bellows Booth, the artist's granddaughter.

For sharing his insights and much of his time and energy throughout the preparation of this volume, we thank Nathan A. Haverstock.

Our wonderful partner, Merrell Publishers of London and New York, was essential to the fruition of this book. Hugh Merrell has supported us through, now, four publications, and we look forward to more. Joan Brookbank, US Director, is a colleague in every sense of the word. Nicola Bailey, Michelle Draycott, Sadie Butler, Helen Miles, Paul Shinn, Claire Chandler, and Anthea Snow employed their considerable talents to make this a beautiful, reader-friendly book that will reach Bellows lovers around the world, and we thank them.

This publication was made possible, in part, through the generous support of the Mrs. Richard M. Ross Publications Fund of the Columbus Museum of Art.

Finally, Christopher S. Duckworth, Chief Editor and Head of Publications, has wanted to do a Bellows book even before he came to the Museum some two years ago. Here it is.

Nannette V. Maciejunes, Executive Director
Columbus Museum of Art

Introduction

I am always very amused with people who talk about lack of subjects for painting. The great difficulty is that you can not stop to sort them out enough. Wherever you go, they are waiting for you. The men of the docks, the children at the river edge, polo crowds, prizefights, summer evenings and romance, village folk, young people, old people, the beautiful, the ugly. Everywhere the difficulty that I have had, even when I was quite young, was to stop long enough to do the thing. As a student I was always eager to do the tremendous, vital things that pressed all about me. It seems to me that an artist must be a spectator of life; a reverential, enthusiastic, emotional spectator, and then the great dramas of human nature will surge through his mind.

George Bellows, "The Big Idea," *Touchstone*, July 1, 1917

AS a dedicated "spectator," Bellows might have mentioned a good many other subjects that drew his attention over the years: traffic jams, construction sites, bridges, parks, playgrounds, street fights, cows, horses, oxen, pigs, and chickens, not to mention a parrot or two, barges, tugboats, dories, fishing smacks, ocean liners, beaches, snowdrifts, mountains, valleys, lakes, ponds, and islands. He studied these subjects not only when the conditions were favorable, but also when it was raining, snowing, overcast, or long past midnight.

As for "dramas of human nature," there is something happening in almost all of Bellows's pictures. People, singly or in crowds, are laboring, playing, skating, swimming, chatting, or just walking along. He saw human activity everywhere on his long rambles through city streets and country lanes. He had an uncanny way of storing up these impressions and images, committing them to memory with photographic accuracy. Days or even years later he would reassemble them in the studio, on the spacious canvases for which he was noted.

Almost everything about Bellows was big, not only his prize-winning pictures but also the brushes he used to paint them. Bellows himself was big, from the top of his bald head down to his size twelve shoes, six feet two inches below. He had a big, resonant baritone voice, which he used to advantage in church choirs, at the ballpark, on the lecture podium, and on the amateur-theater stage. When necessary, he employed it to win arguments, too.

Bellows's capacity for enjoyment was almost unlimited. He loved to read and to go to plays and concerts and parties and restaurants. Sports and games exhilarated him—from basketball to penny-ante poker. He treasured his family and friends, and went out of his way to help and nurture young artists less fortunate than himself.

"Above all he had a heart," said his friend Eugene Speicher, "and used it at all times."

The Boy from Columbus

Some day when I have time, I may travel and see the world.
I would not expect to find very many better pictures than
have been brought to me here . . .

George Bellows to Miss Mary McCaulley, 1920

GEORGE Wesley Bellows's father was sometimes described as a "tightfisted Yankee." He was indeed careful with his dollars, and he also was a true Yankee, at least by descent, for his ancestor John Bellows had arrived in Massachusetts in April 1635, age twelve, on the *Hopewell* out of London. His youngest son, Benjamin, was born in Marlborough, Massachusetts, in 1678, and in time Benjamin made his way up the Connecticut River, where he founded the village of Walpole, New Hampshire. Across the Connecticut rapids lies the Vermont city named Bellows Falls.

Land was plentiful in those days and, by 1827, when George's father was born, a branch of the family had migrated to Suffolk County, New York, and taken up farming in Hampton Bays, on the south shore of Long Island. At an early age, George Bellows, Senior, was apprenticed to a carpenter in Brooklyn, New York, and it was as a journeyman that he came to Columbus, Ohio, in 1859. Within a year, he had put down roots in the rapidly growing

George Bellows, Senior
Circa 1880
Amherst College Archives and Special Collections, Amherst, Massachusetts: George Wesley Bellows Papers, Box 5, folder 6

Anna Smith Bellows
Circa 1880
Amherst College Archives and Special Collections, Amherst, Massachusetts: George Wesley Bellows Papers, Box 5, folder 6

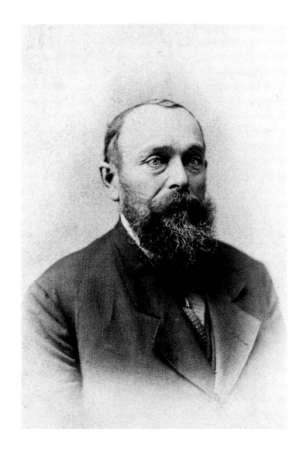

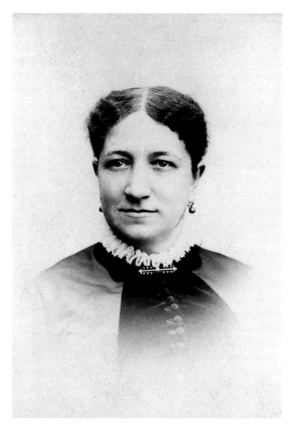

George Bellows, age 3½
1886
Amherst College Archives and
Special Collections, Amherst,
Massachusetts: George Wesley
Bellows Papers, Box 5, folder 1

All dressed up for the
photographer, George Bellows
bravely holds very still. In later
years, he painted many portraits
of his own young children and
paid them not to talk or squirm.

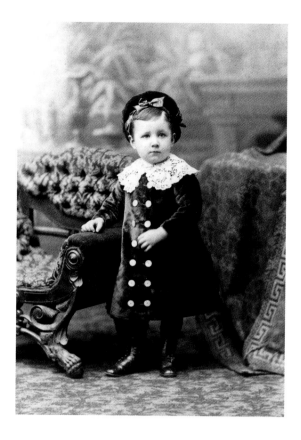

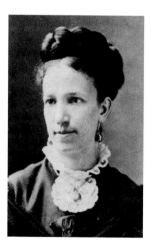

Elinor "Aunt Fanny"
Smith
Undated
Amherst College Archives and
Special Collections, Amherst,
Massachusetts: George Wesley
Bellows Papers, Box 5, folder 6

capital (population 17,882). According to the
1860 census, he had a house of his own in
the Fourth Ward, occupied by himself, his
wife, Lucy (*née* Squires), his brother Charles
(a carpenter and builder), his brother-in-law
J. Hamilton Squires (an apprentice carpenter),
and a German maid. And soon there was a baby
daughter, Laura.

From this time on, "Pa" Bellows preferred
to be known as an "architect," but his real
talent lay in the conscientious supervision
of construction for important building projects
largely designed by others: the Central High
School, the Ohio Institution for the Education
of the Deaf and Dumb, the Franklin County
Court House, the First Methodist Episcopal
Church, and the Chittenden Hotel among them.

Lucy, his first wife, remembered on the 200
block of East Rich Street as an "exceptionally
friendly" woman, died before Laura's twentieth
birthday. Feeling the importance of female
companionship for his daughter, George
Bellows, Senior, returned to Long Island to

seek a new bride. He selected Miss Anna
Wilhelmina Smith, of Sag Harbor, the spinster
daughter of a whaling captain. Anna settled into
the Rich Street house and, on August 12, 1882,
she delivered a baby boy, George Wesley
Bellows, whose middle name was chosen
out of respect for John Wesley, the founder
of the Methodist faith.

Methodism was taken very seriously in
the Bellows household, especially by the elder
George, who undertook almost everything
methodically—his work, his religious life,
and his roles as citizen and father.

In a sense, young George was raised as an
only child, for in his mother's eyes that was
what he was. He had his half-sister, Laura, to
play with until she married and moved away
when he was two. And there was his mother's
sister Elinor ("Aunt Fanny"), who was always
around to teach him the ABCs and tuck him
in at night, and later to praise his childish
drawings. Not that Anna Bellows was
indifferent or lazy. She was just sedentary.
Past forty when she became a mother, she was
nearly six feet tall and weighed, by her son's
estimate, some two hundred pounds, so she
was happiest reposing in her chair while the
maid took care of the housework. Little George
was her pride and joy. She loved and
understood him, and she let him know it.

In later years, when asked how he managed
to launch an artistic career in Columbus, Ohio,
of all places, Bellows had a ready answer.
"I arose surrounded by Methodists and
Republicans," he would reply, explaining that
he and his mother had a regular Sunday routine,
a way to have fun without actually violating the
strict Methodist rules against worldly pastimes
on the Sabbath. After church and a big Sunday
dinner, Pa Bellows always spent the afternoon
upstairs, napping and reading the newspapers.
Downstairs, George could draw and scribble
as he pleased, quietly, using discarded scraps

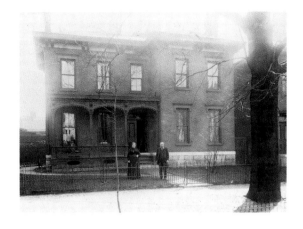

of paper from his father's drafting-table while his mother read to him from the Bible.

During the rest of the week George, like most Columbus kids of his generation, was free after school to play marbles, climb trees, play catch, fly kites, walk fences, go skating or even fishing, just so long as he was home for suppertime. But the girls and boys on Rich Street often chose to hang around instead outside the Bellows house to watch the fun. Long afterward his next-door neighbor Harriet Kirkpatrick (*née* Rhoads) recalled:

Whenever I think of George, I think of a solemn little boy who sat on our stone front steps drawing on yards of ribbon paper. It was a command performance, and we would pay him with dates and figs. Since my father was an importer of fine groceries, it was easy for us to provide these rarities. There would be heated arguments as to what George was to draw. Since the paper was long and narrow, trains and circus parades were the favorites. It mattered not at all to George for he could draw anything we asked for. The boys preferred the trains, starting with the engine and ending with the caboose. But I preferred the parades with the long lines of animals ending with the calliope. In the midst of his drawing, George would stop, look up and say, "I have to be fed!" Whereupon he would be given a date or a fig. Then back to work he would go although drawing was never work to him. I used to save these drawings and pin them up on the wall of my room. But what eventually became of them I do not know.

Brownie Roster
Circa 1899
Watercolor and ink on paper
15 × 11 in. (38.1 × 28 cm)
Amherst College Archives and
Special Collections, Amherst,
Massachusetts: George Wesley
Bellows Papers, Box 9, folder 3

By age sixteen, George was
general manager of all three
Brownie Athletic Club teams:
baseball, basketball, and
football. "He was not content to
be ranked as *good* at anything.
He wanted to excel," a
teammate recalled. "Day after
day, weeks on end, he would
practice throwing the ball to
first base from a certain point
until he could field the ball
cleanly and gracefully from
every part of the territory."

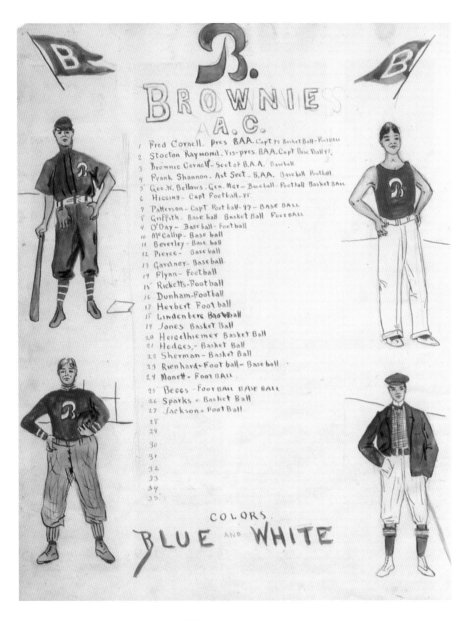

Some time in the mid-1890s, George,
something of a loner, developed a fascination
for baseball, watching the neighborhood
sandlot games keenly and yearning to join in.
He made several attempts but was always
turned down because, though he was old
enough to play, the boys thought he was too
short and too awkward-looking. Grudgingly,
one team finally agreed to take him on as
scorekeeper. One day, when a player failed to
show up for a big game, the captain handed him
a glove and ordered him out to right field. To the
amazement of all, George knew exactly what to
do, and he did it. He got to keep the glove.

At that time, sandlot baseball in Columbus
was evolving into an organized sport. Regular
season schedules were announced in advance,
team rosters became more selective, and rules
were enforced much more strictly. In 1897,
as Bellows was turning fifteen, a new
organization emerged on the East Side, calling
itself the Brownie Athletic Club. That first
season, with Bellows, a left-handed-hitting

**"George Bellows: One
of the Old Brownie
Lads"**
The Columbus Dispatch,
Columbus, Ohio, July 5, 1903,
Section 3, page 9

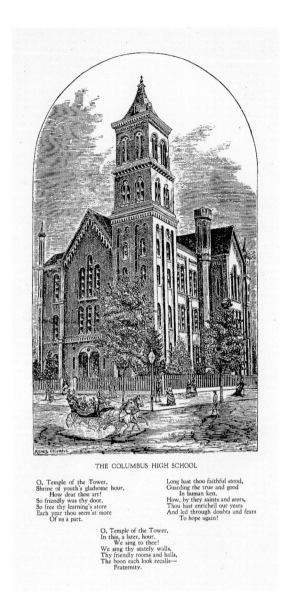

THE COLUMBUS HIGH SCHOOL

O, Temple of the Tower,
Shrine of youth's gladsome hour,
How dear thou art!
So friendly was thy door,
So free thy learning's store
Each year thou seem'st more
Of us a part.

Long hast thou faithful stood,
Guarding the true and good
In human ken.
How, by they saints and seers,
Thou hast enriched our years
And led through doubts and fears
To hope again!

O, Temple of the Tower,
In this, a later, hour,
We sing to thee!
We sing thy stately walls,
Thy friendly rooms and halls,
The boon each look recalls—
Fraternity.

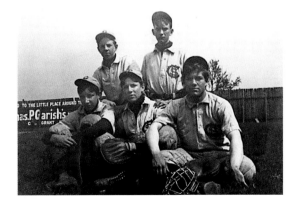

and right-handed-fielding infielder, the
Brownies won twenty-five of their twenty-eight
games. By 1898, he was managing all of the
three Brownie teams—baseball, basketball,
and football.

In September 1897, Bellows entered Central
High School. It was a huge, multi-towered
building, altered and expanded under his
father's supervision years before, and filled
with kids he did not know. Taller now, and
locally famous among sports fans, he was still
far less self-confident than he would become in
later life. As a result, he overcompensated, and
many of his new classmates sized him up as
"opinionated," "loud," "swaggering," and
"cocky." Worse yet, word got around that
George Bellows was an "artist," and art was
something only girls went in for. Of course,
when they saw Bellows at shortstop, or playing
center-forward on the basketball court, they
began to change their minds. George was a
"regular guy" after all.

Unbeknownst to the teenage set, art was
taken very seriously in Columbus. In 1877, a
group of citizens had formed the Columbus
Art Association, and two years later they
had opened the Columbus Art School. Once
that was launched, they began making plans
for a gallery of fine arts to serve the entire
community. Even in those days, the city was
blessed with several valuable art collections,
but they were in private hands and none could
be visited without an invitation, except for the
large collection belonging to merchant
banker–philanthropist Francis C. Sessions,
who often opened his East Broad Street house
to the general public.

Moreover, Columbus was home to more
than twenty professional artists, any of whom
might have been happy to give private lessons
to such a precocious young aspirant as
George—but neither he nor his parents seems
to have noticed; in fact his parents assumed he

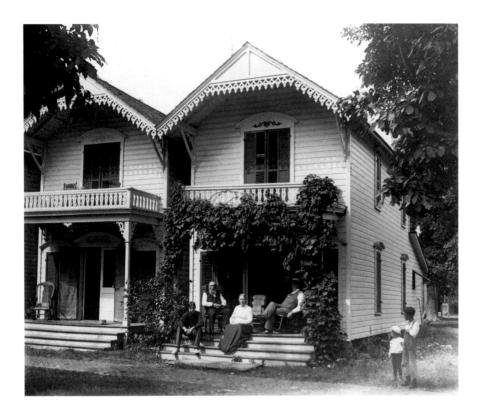

George Bellows with his Mother and Father at a Summer Cottage in Lakeside, Ohio
Circa 1900
Amherst College Archives and Special Collections, Amherst, Massachusetts: George Wesley Bellows Papers, Box 5, folder 2

George's family often spent a few weeks at this pleasant Methodist retreat on Sandusky Bay, built in the heyday of the Chautauqua movement, where wholesome activities for all ages were offered daily. The prevailing architectural style was Carpenter Gothic.

Columbus YMCA Basketball Team
1902
Collection of Sarah Kriska

Although Bellows's first sport was baseball, his height and athletic ability also made him a hardwood star (seated left).

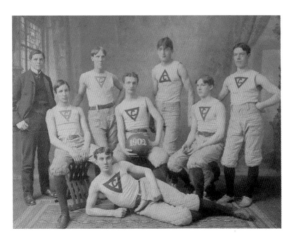

would "grow out of it" and become a banker, a clergyman, or a contractor like his father.

Fortunately, the Columbus public school system was widely known in educational circles for the quality of its art program, which was rated by the National Education Association one of the four best in the entire country in 1883. The other three were in Massachusetts, all modeled on the Columbus course of study. At Central High School, the art classes, open to all students, were led by Miss Elizabeth L. Crook, a capable watercolorist who had diplomas from both

the Columbus Art School and the Pratt Institute in Brooklyn, New York.

In addition to his athletic activities, Bellows was required to undertake a rigorous academic curriculum that included four years each of mathematics and science, a foreign language, English, history, and literature. There were also such alluring electives as choral singing—at which he excelled—and, of course, art.

In 1900, during his senior year at Central High, Bellows starred in what could be considered his first "one-man show," consisting of a group of drawings prominently displayed in the windows of Baker's Art Gallery, the city's leading photography studio. The subject of the exhibition was Commodore George Dewey's decisive 1898 naval victory in Manila Bay over the dreaded Spanish fleet; the scenes were undoubtedly inspired by the vivid eyewitness renderings by John T. McCutcheon of the *Chicago Tribune*. At the end of his senior year, Bellows delivered a lively class oration, in chalk-talk format, entitled "Art Education in the Public Schools." Then, on the strength of his showing at Baker's, he landed a summer job as an assistant illustrator at the *Columbus Dispatch*.

After all this public attention, he had a right to feel a bit cocky on registration day, when he enrolled for the fall term at Ohio State University. Chartered in the early 1870s as a land-grant school called the Ohio Agricultural and Mechanical College, it was still "more land than college" in 1901. To be sure, the fields were now also strewn with large, stolid buildings, and the institution was well on its way to achieving the esteem it enjoys today. Then, as now, a fair share of that prestige had to do with intercollegiate sports.

Accordingly, Bellows, and several former members of the Brownie Athletic Club, counted on joining the Ohio State baseball lineup. But there were no vacancies on the team that year.

Years and years of practice are
needed to master the art of
drawing with pen and ink; the
slightest moment of hesitation
and all is lost. For the Ohio
State University yearbook,
The Makio, Bellows wielded
his pen like a rapier, pinioning
both students and faculty with
equal gusto.

Fortunately, the game of basketball, invented in
1891, was second nature to Bellows, already
known at the YMCA for his grace and skill as
center-forward on the court.

For some reason, art classes were not
offered to first-year students, so Bellows settled
for an eclectic array of subjects, including
zoology, physiology, European history, rhetoric,
and English literature. Physiology acquainted
the future artist with the human anatomy and
all its mechanisms. Rhetoric would later stand
him in good stead as a teacher and lecturer. The
one freshman class that truly changed his life,
however, was English literature—not just
because of the content but because of the man
behind the lectern, Associate Professor Joseph
Russell Taylor, himself an alumnus of Central
High. A fine scholar, and a published poet,
Taylor took a shine to this six-foot-two
freshman, kept an eye on him, and eventually
gained his confidence. There was some trouble
at home, Taylor learned: George, Senior, would
not tolerate any talk about his son's unrealistic,
impractical career plans. In his view, there was
no way a so-called artist could ever hope to
become successful or rich like himself. The
whole idea was out of the question, period.

It was Professor Taylor who advised the
young man to stand firm and to keep his hopes
alive. Another of Taylor's pupils, James
Thurber, included a piece on Taylor in
The Thurber Album, a long reminiscence
entitled "Man with a Pipe":

> *Taylor usually wore a brown suit, and he
> always brought to class the light of the
> enchanted artistic world he lived in, of whose
> wonders he once said, "It is possible that all
> things are beautiful." His influence was not
> confined to students who hoped to become
> writers or teachers of English. A dozen years
> before my day at the university, he had
> tolerated the occasional classroom inattention*

20

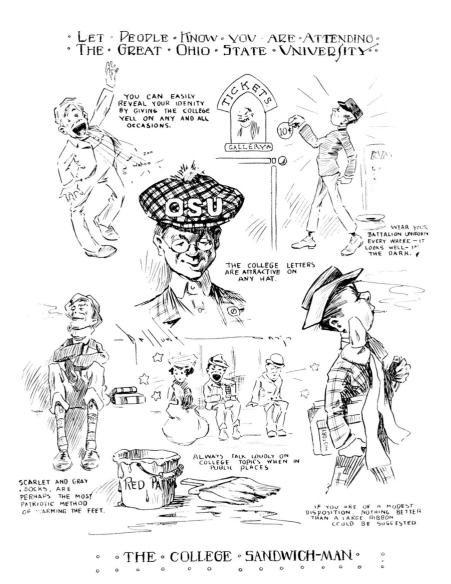

YOU CAN EASILY
REVEAL YOUR IDENTITY
BY GIVING THE COLLEGE
YELL ON ANY AND ALL
OCCASIONS.

TICKETS
GALLERY

10¢

WEAR YOUR
BATTALION UNIFORM
EVERY WHERE — IT
LOOKS WELL — IN
THE DARK.

THE COLLEGE LETTERS
ARE ATTRACTIVE ON
ANY HAT.

ALWAYS TALK LOUDLY ON
COLLEGE TOPICS WHEN IN
PUBLIC PLACES

SCARLET AND GRAY
SOCKS, ARE
PERHAPS THE MOST
PATRIOTIC METHOD
OF WARMING THE FEET.

RED PAINT

IF YOU ARE OF A MODEST
DISPOSITION, NOTHING BETTER
THAN A LARGE RIBBON
COULD BE SUGGESTED

· · THE · COLLEGE · SANDWICH-MAN ·

The College Sandwich-Man
1903
Pen and ink on paper
9½ × 7 in.
(24.1 × 17.8 cm)
The Ohio State University Photo
Archives, Columbus, Ohio

of a young man who was given to drawing, in his notebook, prizefighters without faces, and other unique figures. The student was a Columbus boy named George Wesley Bellows, whose parents had been dismayed, rather than delighted, by their son's devotion to the idle practice of drawing pictures. Luckily for him, his professor not only was something of a painter himself but had taught drawing for several years before he became a teacher of English. Close students of Bellows's life have recognized Joe Taylor's lively and lasting interest in his young friend's talent, and most of them feel that without this encouragement the artist might never have become a professional. Joe Taylor was, for one thing,

a friend of Robert Henri, Bellows's first influential teacher, and he seems to have brought the two men together.

During his remaining college years, Bellows could, and did, take advantage of almost all the available art classes. The department was headed by Silas Martin, a Columbus native noted for his portraits of prominent local citizens and for the watercolor landscapes he painted along the Scioto and Olentangy rivers. His department, however, was focused on meeting the needs of future architects, draftsmen, patent agents, and industrial designers. The few painting courses dealt solely with watercolor technique, stressing "color theory," "atmosphere," and "values."

Bellows explored other academic areas as well—economics, for example, and philosophy—and even an introductory course in law (perhaps to appease his worried parents). He passed all his sophomore-year subjects, earning average grades, roughly equivalent to a "gentleman's C," except in the art classes and Taylor's English literature, where his performance was rated "M" for "meritorious."

Now a busy caricaturist and illustrator for the OSU yearbook and other campus publications, Bellows also elected a course in lettering. This enabled him to sign his drawings with gusto in an almost infinite number of distinctive styles.

Sophomore year opened up vacancies on the baseball team, which were quickly filled by former Brownies, including their dazzling shortstop. Bellows also filled in from time to time at every other position except catcher and pitcher. And the prestigious Beta Theta Pi fraternity, taking a second look at this phenomenal athlete, belatedly pledged him. Memories of his hazing proved indelible: fourteen years later the subject of one of

Bellows's earliest and most troubling lithographs was *Initiation in the Frat* (see p. 115).

The university's course catalogues did not specifically mention oil painting as an art department option, but somewhere along the way Bellows became so proficient in the medium that when, in the late summer of 1903, he submitted an oil study to the Ohio State Fair art jury, it earned a cash prize for "best still life in oil, original design." At this time, the Ohio State Fair juries were not just looking for prize poultry, pigs, and pumpkins. The fair also provided a unique opportunity for large crowds of people to walk through the fine-arts building and admire the best efforts of painters, sculptors, and photographers from all over Ohio and beyond.

This particular picture (unlocated) raises some interesting questions: how and when did

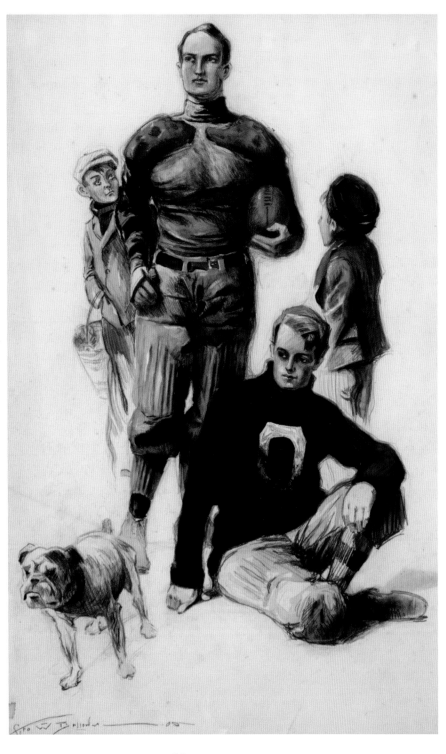

Untitled
Circa 1903–04
Graphite, watercolor, and
gouache on paper
26 × 17 in. (sight)
(66 × 43.2 cm)
Theta Delta Chapter of Beta
Theta Pi Fraternity and the Ohio
State University Alumni
Association, Columbus, Ohio

Untitled
Circa 1903–04
Graphite, watercolor, and
gouache on paper
26 × 17 in. (sight)
(66 × 43.2 cm)
Theta Delta Chapter of Beta
Theta Pi Fraternity and the Ohio
State University Alumni
Association, Columbus, Ohio

Senior Prom
Circa 1903–04
Graphite, watercolor, and
gouache on paper
26 × 17 in. (sight)
(66 × 43.2 cm)
Theta Delta Chapter of Beta
Theta Pi Fraternity and the Ohio
State University Alumni
Association, Columbus, Ohio

The Pledge
Circa 1903–04
Graphite, watercolor, and
gouache on paper
26 × 17 in. (sight)
(66 × 43.2 cm)
Theta Delta Chapter of Beta
Theta Pi Fraternity and the Ohio
State University Alumni
Association, Columbus, Ohio

These handsome drawings of
campus and fraternity-house
types provide an early
indication of Bellows's great
versatility as an illustrator. He
left them behind at Beta House
when he went to New York City.

Bellows learn to use oils? And why did this athletic, outdoorsy young man choose still life when he never again showed the least interest in such inert subject matter? Whatever his reasons, the prize may have further strengthened his resolve to seek a career in art.

Bellows never finished his junior year at Ohio State. Scouts from pro and semi-pro baseball teams, reportedly including the Cincinnati Reds, were imploring him to sign on, but he gave them no encouragement, for by now he had decided that OSU had very little more to teach him—at least where art was concerned—and he needed to keep growing.

Deliberately, he "forgot" to show up for his final examinations in the spring of 1904, which meant failure in all his third-year courses and, of course, no advancement toward graduation next year. It was a bold and risky move, but it worked: Pa Bellows finally understood that his

boy was really and truly serious. Some time during the summer of 1904, the two worked out a compromise. George could move to New York City with his father's blessing and his promise of a $50 allowance every month until he got on his feet. The tightfisted Yankee, however, would not under any circumstances defray any additional expenses.

Before he left, Bellows won four more state fair awards, in the form of cash, for three drawings and a watercolor landscape. That, along with the paychecks he received for his summer jobs as a substitute sportswriter at the *Ohio State Journal* and the *Columbus Dispatch*, would tide him over for a while at least. Soon he was on the train heading, he imagined, toward the day when he would become a successful magazine illustrator like his idols Charles Dana Gibson and Howard Chandler Christy.

Cheerleader
Circa 1903–04
Graphite, watercolor, and
gouache on paper
26 × 17 in. (sight)
(66 × 43.2 cm)
Theta Delta Chapter of Beta
Theta Pi Fraternity and the Ohio
State University Alumni
Association, Columbus, Ohio

24

"The Boss"

Forget the routine thing, forget the college degree. The man of vitality is naturally self-educated. Education is largely personal. The young man with initiative will try to find a great man in his own field, will attach himself to him, will pay him some way to accept him as an apprentice.

You do not know what you are able to do until you try. In learning a topic, whether it be painting, or housekeeping, or building, or any other art, consider every method that can be followed. Try it in every possible way. Be deliberate. Be spontaneous. Be thoughtful and painstaking. Be abandoned and impulsive, intellectual and inspired, calm and temperamental. Learn your own possibilities. Have confidence in your self-reliance!

George Bellows, "The Relation of Art to Every-day Things,"
Art and Decoration**, **July 15, 1921

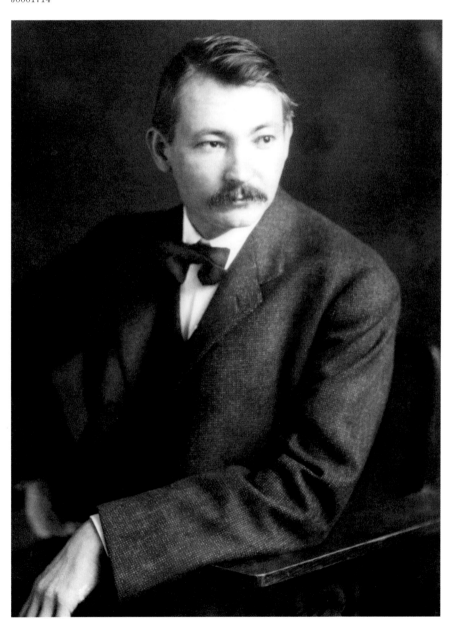

Robert Henri
Circa 1905
Smithsonian American Art
Museum, Washington, D.C.,
Peter A. Juley & Son collection,
J0001714

THE New York School of Art at Sixth Avenue and Fifty-seventh Street was just around the corner from a well-equipped YMCA, so George took a room there before seeking out Professor Taylor's friend Robert Henri.

The so-called Chase School, founded in 1896, was small compared with the seventy-nine-year-old National Academy of Design or the Art Students League, which opened in 1875, so it was possible Henri's classes might already be filled. On the contrary, Bellows learned, Henri was traveling in Europe and not expected back until early November. In the interim a young man named Kenneth Hayes Miller would be in charge.

Miller's job was to teach illustration, which he did with confidence, but he had not been fully prepared to deal single-handedly with Henri's rowdy pupils. Henri usually tolerated practical jokes, raucous laughter, and occasional paint-fights because they relieved tension in the classroom. He urged his pupils to loosen up. His message, in effect, was not to stop to rearrange, to organize or to analyze. Let what you see travel directly from your eye to your hand the way a newspaper illustrator would do it at the scene of a fast-breaking story. "Do it all in one sitting if you can," he chanted. "In one minute if you can."

Guy Pène du Bois, an exact contemporary of Bellows, had the dubious honor of serving for several years as class monitor for "that rough-riding gang," which included Gifford Beal, Glenn O. Coleman, Edward Hopper, Rockwell Kent, Walter Pach, poet Vachel Lindsay, Edward Keefe, actor Clifton Webb, and now Bellows. "I use that term advisedly," he continued, "for its members delighted in the Rooseveltian contribution to the color of the period: the word 'strenuous.' They took up boxing, handball, all sorts of gymnastics, chinning themselves with the lightest finger grips over all the door lintels."

By the time Henri returned from his extended summer holiday, Bellows had heard all about him—and also about William Merritt Chase, who ran the school but seldom appeared there. Chase, a super-successful "society" painter, had a reputation among the students for showing off. For one thing, he dressed like a fashion plate, in spotless haberdashery, white boutonnières, pince-nez, and spats. For another, he boasted about the speed and bravura of his brushstrokes, claiming he could produce a finished full-length portrait in an hour or less—and several times a year he proved it before a packed audience of invited guests.

Perhaps most troubling of all was his double-edged sense of humor, because one never knew when to expect it. In one famous exchange the victim was a newly enrolled female student:

"Who painted these pictures?"

"I did, Mr. Chase."

"I don't understand them at all."

"Oh, but I *felt* that way, Mr. Chase."

"Madam, the next time you feel that way, DON'T PAINT."

Finally November arrived, and with it Robert Henri, affectionately known as "The Boss" by those in his classroom. Over the next two decades, Henri and Bellows would enjoy a comfortable father–son relationship the likes of which George had not known before. At first Henri pointed the way and Bellows followed, but in time, as sometimes happens, the pupil outstripped the master. Not that the relationship was in any way competitive. They had so much in common, on many levels, that their rare fallings-out didn't threaten their comradeship.

Both men were born in Ohio, for one thing. Henri's father, John Jackson Cozad, once a riverboat gambler, became a land speculator soon after his son's birth, in 1865, and his family ended up in Nebraska, where Cozad dreamed of erecting a city on the prairie. Growing up in isolation, young Robert became fascinated by the wondrous illustrations he saw in the popular magazines. He cut them out, collected them in scrapbooks, and taught himself to draw, just as Bellows later did, by copying them over and over again until he got them "right."

Inevitably, one day Henri's father got into a debate with a land-hungry, knife-wielding rancher, shot at him, and panicked about the consequences. To evade the law, all the Cozads changed their names and fled to Atlantic City, New Jersey. Robert Henry Cozad chose the alias Robert Henri (pronounced "Hen-rye"), and, although the Nebraska posse (if there was one) never caught up with him, it seemed easier to keep the strange new identity permanently.

Several accounts of the first Henri–Bellows encounter have survived, suggesting that there may have been witnesses. George, presumably armed with Professor Taylor's letter of introduction, offered Henri his portfolio of pen-and-ink drawings, the best of his Gibson and Christy imitations. Solemnly, Henri looked them over, then inquired, "Haven't I seen these before?"

Henri loved nothing better than to discover real talent, so that he could redirect it, replacing imitation with genuine, robust self-expression. One of his favorite aphorisms was "A big painter is one who has something to say. He thus does not paint men, landscapes, or furniture, but an idea." This young man had just the potential he was looking for.

Henri was not the only person in New York who found George Bellows interesting. Miss Emma Louise Story, an attractive and intelligent art student at the Art Students League, also took a shine to the tall, easygoing fellow, and, as early as October, she began spending noontime breaks with him in nearby Central Park. She was a native New Yorker who had grown up across the Hudson in Montclair,

New Jersey, next door to the big studio where George Inness was then working on some of his finest late landscapes. After her high school graduation, in 1902, she was faced with a choice: art or music? She had opted for art, as an experiment.

Since George could not afford to spend that Christmas in Columbus, Emma invited him to share the day with her family in Upper Montclair, where they now lived. Bellows, no lover of small talk, failed to impress the elder Storys, who told Emma as much. But she knew her own mind and continued to go with him to parties, plays, and restaurants whenever she pleased.

It was not easy for Henri's full-time pupils to find time for social life. Every morning there was a lengthy life class, followed in the afternoon by portraiture, which could last far beyond the scheduled dismissal time. On Saturdays came "Composition," which sometimes entailed a trip to the Metropolitan Museum of Art to study the works of such Masters as Manet, Velázquez, Corot, Hals, and Rembrandt.

Usually, though, Saturday was Henri's day to critique the week's classroom efforts. During these sessions, which most students found the best part of the week, The Boss did all the talking, while his pupils listened attentively, their minds not distracted by works in progress. He spoke encouragingly about each painting, praising the parts he especially liked, avoiding the acerbic remarks for which Chase was known and feared. Always he reminded the young artist, "Don't take me as an authority. I am simply expressing a very personal point of view. Nothing final about it. You have to settle all of these matters for yourself."

The City

I do not see why a man should wait a minute to begin work after he has any security in his technique; because the way to become a painter is to paint. There are only three things demanded of a painter: to see things, to feel them, and to dope them out for the public. You can learn more in painting one street scene than in six months' work in an atelier. My advice is to paint just as soon as you have the confidence to, and keep your ideals aloof to criticize your painting with. Watch all good art, and accept none as a standard for yourself. Think with all the world, and work alone.

George Bellows, "The Big Idea," *Touchstone*, **July 1, 1917**

AT twenty-two, Bellows could still pay attention in a classroom when the subject interested him, and he absorbed Henri's pithy aphorisms with enthusiasm. Years later he was able to recite them verbatim—especially those about being one's own man, unafraid to question the age-old "laws" of aesthetics. Henri abhorred "pretty pictures," insisting, like the poet Carl Sandburg, that true beauty was to be found in unexpected places.

As soon as Bellows had mastered the necessary studio techniques, Henri ordered him out into the streets of Manhattan to see what was real, and therefore truthful and beautiful, in contemporary life. He began his peregrinations in 1905, and, still a visitor in a strange land, he headed for the inviting parks and playgrounds near the School of Art. Very few of his first New

Central Park
1905
Oil on canvas
21½ × 25½ in.
(54.6 × 64.8 cm)
The Ohio State University
Faculty Club, Columbus, Ohio:
Loaned in perpetuity to the
University by Mr. and Mrs. Roy
L. Wildermuth

One of Bellows's favorite
haunts was Central Park, where
something paintable usually
presented itself. On this
pleasant spring day, little
clusters of spectators await a
sporting event of some sort
beside a grassy playing field,
while, in the foreground,
passing horse-drawn carriages
provided a sense of motion.

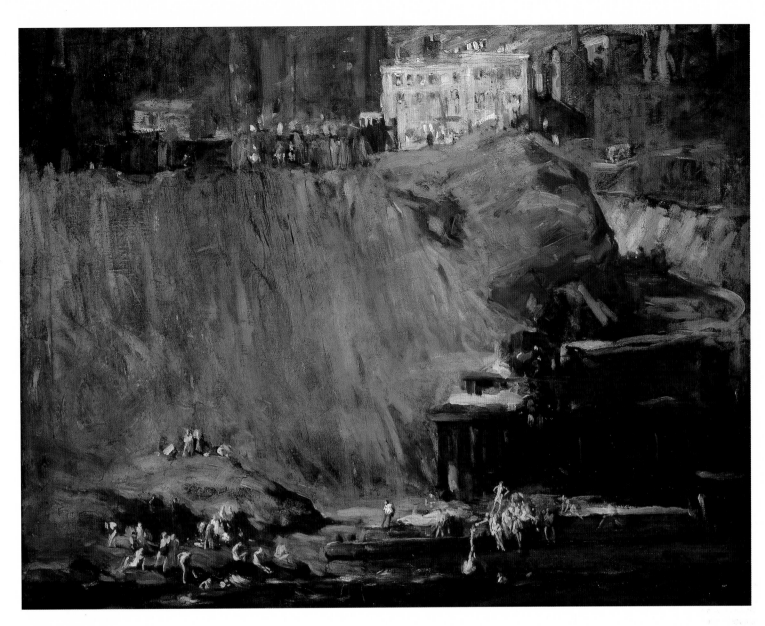

River Rats
1906
Oil on canvas
30¹/₂ × 38¹/₂ in.
(77.5 × 97.8 cm)
Private collection, Washington, D.C.
Photograph courtesy of Keny
Galleries, Columbus, Ohio

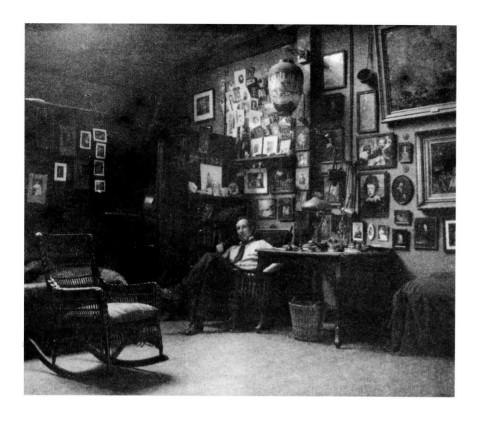

Bellows in his Studio
1908
Amherst College Archives and
Special Collections, Amherst,
Massachusetts: George Wesley
Bellows collection, Box 5,
folder 1

The studio where Bellows lived
and worked from 1906 until
1910 was decorated with
reproductions and photographs
of Old Master paintings,
"artistic" bric-a-brac, and other
accessories found in every
respectable atelier at the turn
of the last century. His favorite
chair was the wicker rocker at
left, which he often set into
rapid motion while collecting
his thoughts.

York paintings seem to have survived; Bellows
often recycled his canvases to save money.
One, now in a private collection, was *Winter
Afternoon, Riverside Park* and another, entitled
Central Park (see p. 30), is a scene of early
summer near the Sheep Meadow, which now
hangs in the Ohio State University Faculty Club.

By the end of the summer, Bellows, tiring of
the YMCA, found a decent furnished room in a
brownstone on Fifty-eighth Street that could
accommodate up to three people. The second
was Ed Keefe, a classmate. The third man
sharing the expenses was usually Fred Cornell,
a former Brownie who had lettered at OSU in
baseball, basketball, football, and track.
Bellows spent a week or two on Long Island,
swimming, crabbing, boating, and visiting
relatives in Sag Harbor; then, rested and
refreshed, he returned to school in September
only to learn that Henri was again delayed in
Europe. This time his substitute would be
The Boss's friend John Sloan, a former
newspaper artist from the *Philadelphia
Inquirer*, trained, as Henri had been, at the

Pennsylvania Academy of the Fine Arts. Often
described as one of the earliest New York
realists, Sloan, like Bellows, had only recently
arrived in the city. Though his methods were
somewhat different—he insisted on teaching
drawing and painting simultaneously—and
though he lacked some of the older man's
charisma, Sloan's instruction was quite
compatible with Henri's.

In due course, Henri returned, and Bellows
continued his weekend explorations, which
now took him well beyond the verdant parks
and wide avenues. The old city was reinventing
itself: the first nine or ten miles of the new
subway were in full operation now, and, out of
sight, more underground tracks were creeping
outward. Blocks and blocks of derelict
tenements were being razed, new docks and
bridges were under construction, and the tide
of immigration was never-ending.

Both Sloan and Henri saw great artistic
possibilities amid this hurly-burly, and the
more venturesome students, including Bellows,
agreed. He haunted the teeming Lower East
Side collecting ideas for future paintings, but
the streets were so crowded and the residents
so inquisitive that he could manage only a few
furtive sketches, relying on his extraordinary
memory to store up his impressions until he
was in the classroom.

Kids (private collection) was one of the first
East Side paintings. In it, eight or nine young
children, some smoking, idle away an
afternoon, attended inexpertly by two slightly
older children with an old graffiti-scarred wood
fence as a backdrop.

Another was *River Rats* (see p. 31), in which
a flock of half-naked boys splash happily in the
polluted water of the East River, dwarfed by a
colossal mountain of dirt or clay, possibly the
detritus of some vast excavation project
dumped there by the steamshovelful. If such
subjects seemed sordid, and many critics found

Portrait of My Father
1906
Oil on canvas
28⅜ × 22 in.
(72 × 55.9 cm)
Columbus Museum of Art,
Columbus, Ohio: Gift of Howard
B. Monett. 1952.048

This portrait, painted in
Columbus in just under three
hours, has as much depth and
empathy as if it had required
many sittings over a period of
days or weeks. It was Bellows's
Christmas present to his father.

them so, Bellows saw them in terms of movement and color. He may well have read Lincoln Steffens's provocative *Shame of the Cities* (1904) or Jacob Riis's *Children of the Tenements* (1903), but social reform was not on Bellows's artistic agenda because, yes, there *was* beauty in the way the other half lived.

Other subjects attracted him as well. There were *Swans in Central Park*, an oil; *Basketball*, a watercolor, shown in March 1906 at the Pennsylvania Academy (one of his first publicly exhibited works since leaving Columbus); and several portraits rounded out the year: an unnamed little boy, a woman named Gladys Findlay, and classmate Clifton Webb, the future film actor, survive on canvas.

During the summer of 1906, Bellows, Keefe, and Cornell moved again. Cornell had found a full-time job, but the other two were eager to have a quiet place to set up their easels. A sky-lighted studio on the sixth floor of the Lincoln Arcade Building, 1987 Broadway, fitted their needs perfectly (see p. 32). Besides a spacious studio, there was plenty of room curtained off for unexpected guests, Glenn O. Coleman, Rockwell Kent, and Eugene O'Neill among them. There was even a kitchen of sorts. Before signing the lease, Bellows made sure he could afford the rent by joining a semi-pro Brooklyn baseball team called The Howards, where, for the first time, he played catcher.

Catchers earned $10 per game, while shortstop paid only $6.

In September, Bellows's Pa and Ma, his half-sister, Laura, and her son Howard visited the new studio on their way home from a vacation in Long Island, and whereas they had referred to the old brownstone room as a sty, they could hardly say the same of Studio 616. Moreover, this was the kind of place to which Bellows could invite his sweetheart, Emma Story, and here, for the first time, he introduced her to everybody.

Bellows spent the Christmas break in Columbus with his parents, who now lived on East Monroe Avenue, near the First Methodist Episcopal Church. While there, he completed a portrait of his seventy-nine-year-old father (see p. 33) and looked up old friends—especially Professor Taylor and former Brownie teammate Stockton "Socks" Raymond. One night during this visit, Raymond took Bellows to the State Hospital for the Insane, where his mother was employed as a matron. The patients were having a dancing party, and benches were provided for onlookers. Seizing this extraordinary opportunity, Bellows made a number of sketches and later, on one large sheet of paper, worked them up into a whirling, laughing, weeping crowd scene, *Dance in a Madhouse*. A decade later it would become the basis for one of his most famous lithographs (see p. 116).

The Academy

All artists are in differing stages of development, some in one direction, others in other directions, some far away, many rather close at hand; but the important fact is this, that with many roads to follow and infinite trails to be cut, many are not taken and no man can follow them all. One body of men, one official jury, will therefore never succeed even in approximating a just presentation of contemporary painting. Some other plan must be arrived at if we are to see represented a fair mart under democratic conditions and under public or semi-public patronage the serious work of the artists of the day. . . . A democratic marketplace, which is needed in this and every city for works of art, must not be entailed by official gentlemen who happen to work their way into positions of power and paternalism.

George Bellows, "An Ideal Exhibition," *American Art News*, December 26, 1914

Frankie, the Organ Boy
1907
Oil on canvas
48¼ × 34¼ in.
(122.6 × 87 cm)
The Nelson-Atkins Museum of Art, Kansas City, Missouri: Purchase: Acquired through the bequest of Ben and Clara Shlyen. F91-22
Photography by Jamison Miller

Posing in Bellows's studio, wearing his Sunday best, a young street musician smiles shyly at the tall man behind the easel. Against the dark background the hands (as often in Bellows's portraits) convey as much, if not more, character as the face.

MOST art students in New York, as elsewhere, are driven by serious professional aspirations and a dream of rising to the top. In Bellows's time, getting to the top, especially at the National Academy of Design, could mean months and years of study in a classroom where the "models" never moved or smiled because they were cast in white plaster from Greco-Roman statuary, and where a painting, be it a portrait, landscape, or still life, had to be so smooth and "finished" that if a single brushstroke could be detected it would receive a low mark.

At the New York School of Art, under Henri, there were very few "rules" indeed, and success was rewarded by something more than fame or riches: self-fulfillment. The Art Students League lay somewhere between the two. As Bellows's classmate Rockwell Kent recalled in his autobiography:

All that we lacked of structural stability, of space, or elegance, they had; all that we had of genius, we believed they lacked . . . Against the fervor, amounting to exaltation, of our student body, they presented, to our minds, the listlessness of dilettantes and of careerists in commercial art. Were other evidence of such a contrast lacking, it appears in our having literally wiped the earth with them in every baseball game we played. We had a league, three teams: the Academy, the League, and we. We never lost a game. But although the student body that we had to draw on was relatively small, we built a team around our stars, and one in particular, George Bellows.

Getting even on the diamond was one thing; getting one's work accepted by the National Academy's exhibition juries was quite another. The budding artists in Henri's classroom, men and women with new ideas, had little chance to see their work on the walls of the Academy's prestigious spring and winter exhibits.

Moreover, the city's commercial galleries, eyeing the bottom line, rarely displayed the work of living American artists, let alone young ones who had something to say.

In early March 1907, an uncharacteristically open-minded Academy jury admitted 378 paintings, including one by George Bellows. It was *River Rats*, painted a year earlier. The fact that Henri happened to be a member of the twenty-seven-man jury made little or no difference: none of Henri's closest colleagues was so fortunate. He immediately resigned from the jury in disgust and began to think about an entirely different way for progressive artists to present their work to the public.

In April a student exhibition was held in the School of Art gallery at Broadway and Eightieth Street. Among the exhibitors were Maine painters Julius Golz and Carl Sprinchorn, painter of Western scenes Homer Boss, and George Bellows. The *New York Times* critic was full of praise for Bellows's wintry view *Pennsylvania Station Excavation* (see p. 49), the first of what would become a series chronicling the ongoing construction of, as *Harper's Weekly* called it, "The greatest Railroad Station in the World." The *Evening Sun* dismissed the exhibition as "gloomy," but John Sloan wrote in his diary that, all in all, it was "a great show. If these men keep on with this work (they don't need to 'improve') it means that art in America should wake. Henri is as proud as a hen with a brood of ducks."

By now Bellows was developing a passionate interest in boxing matches, which, although illegal in public places, could be witnessed regularly in his own neighborhood, in the back room of Tom Sharkey's saloon, just by joining Sharkey's "private club." Prizefights fascinated him because of the swift action in the ring as well as the responses in the crowd during the tense and dangerous moments. His ability to capture these crucial split-seconds—

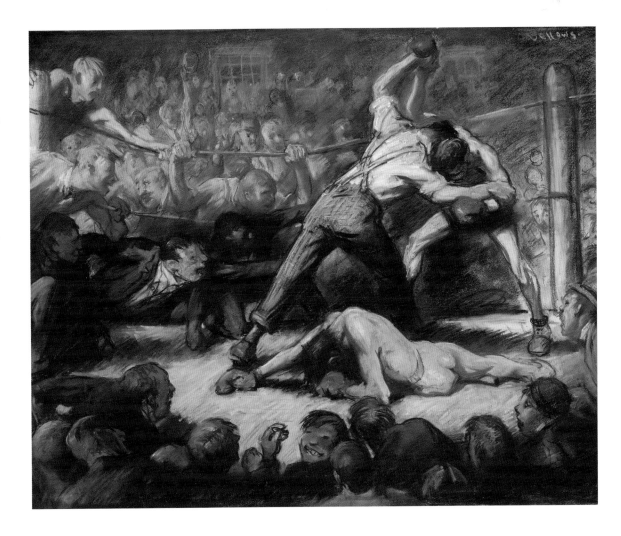

The Knock Out
1907
Pastel and ink on paper
21¾ × 28 in.
(55.3 × 71.1 cm)
Private collection

The Knock Out was drawn from memory shortly after Bellows witnessed this scene at Sharkey's saloon on a stifling night in July. Most of the noisy spectators have rolled up their shirt sleeves, but not the physician at left, who concentrates on the fallen gladiator. The action is all but over, yielding an electrifying air of suspense.

he could not just shout "Hey! Hold that pose!"—bordered on the miraculous.

To be sure, those anatomy classes at Ohio State had taught him the names and uses of all the muscles in the human body, and Robert Henri had expatiated almost daily on the importance of careful composition. To these advantages Bellows added something of his own. Was it an innate kinetic sensibility acquired during his athletic career? Was it a simple love of watching things happen? Was it his trademark, the "slashing brushstroke"? In any case *Club Night* was given wall space at the Academy's winter exhibition in December 1907, and many more boxing drawings, paintings, and lithographs issued from his studio over the next seventeen years.

Pennsylvania Station Excavation was also displayed in this exhibition, indicating that the

Academy's taste might be changing. But Henri and his allies were taking no more chances. He and seven longtime associates were determined to take matters into their own hands instead of facing humiliation, year after year, at the hands of unpredictable Academy juries. Their plan was to find a decent space, hang up a reasonable number of pictures, spread the word, and invite all the critics. Whether the critics loved or loathed what they saw, the artists' names would appear in the daily papers, and people would come flocking to see what all the fuss was about. This strategy had worked in Paris at the Salon des Refusés in 1863; certainly it stood a chance in twentieth-century New York.

The conspirators were eight in number: Ernest Lawson, Maurice Prendergast, Arthur B. Davies, William Glackens, John Sloan, George Luks, Everett Shinn, and Robert Henri. William

Club Night
1907
Oil on canvas
43 × 53 in.
(109.2 × 134.6 cm)
National Gallery of Art,
Washington, D.C.: John Hay
Whitney collection.
1982.76.1.(2867)/PA
Image © 2006 Board of
Trustees, National Gallery of
Art, Washington, D.C.

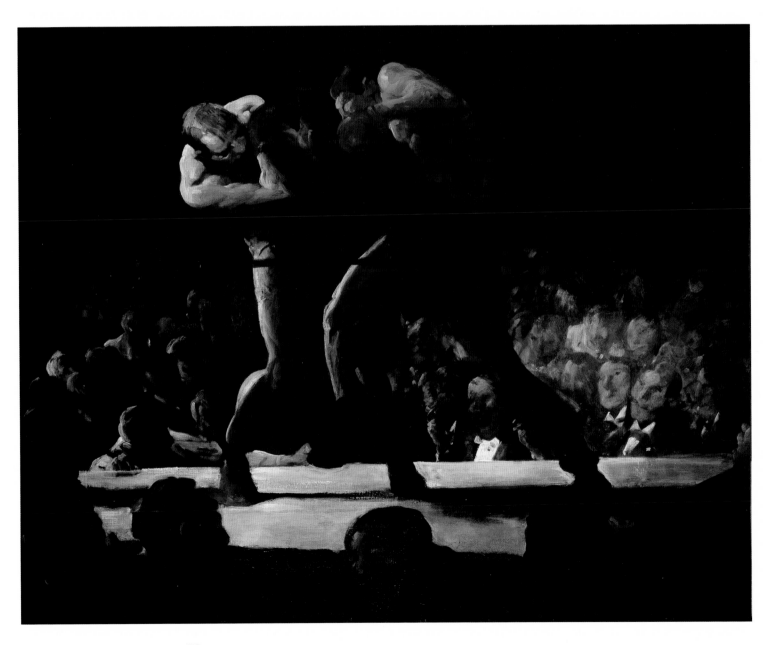

Tin Can Battle, San Juan Hill, New York
1907
Crayon, ink, and charcoal on paper
20 × 23¾ in.
(50.8 × 60.3 cm)
Sheldon Memorial Art Gallery and Sculpture Garden, University of Nebraska-Lincoln, Nebraska: UNL-F.M. Hall collection
Photograph © Sheldon Memorial Art Gallery

The Ashcan School
George Bellows was one of the very few urban-realist artists who actually included ashcans in his pictures—long before the term "Ashcan School" came into general use in the 1930s.

Tin Can Battle is apparently the earliest of at least three depictions of an ashcan in Bellows's œuvre. Here, some young male slum-dwellers, lacking anything else to play with, have found a supply of ammunition in the humble receptacle at the lower left.

"San Juan Hill," on New York City's far West Side, was known for widespread unemployment, truancy, gambling, and general ruffianism. Bellows often recorded such things that others did not, could not, or would not.

Speaking of Bellows and William Glackens in May 1909, a *New York Times* critic wrote: "They err, perhaps, on the side of brutal frankness in their descriptions of childlife in our parks and public squares, but it is indubitably life, and that is the main thing. Their screaming, grimacing, contorted youngsters are notes taken on the spot and published without rewriting."

Bellows's second contribution to Ashcan imagery came soon afterward in a drawing called variously *Hungry Dogs* and *A New York Street Before Dawn*, featuring half a dozen starving feral dogs raiding a huge, overflowing garbage can, in search of something to eat on a midwinter morning.

Macbeth, a relatively adventurous art dealer, gave the group a two-week lease on several of his rooms, beginning February 3, 1908.

Bellows missed the opening: he had gone to Columbus for Christmas, found the place oddly depressing, caught a bad cold, and taken to his bed until he was ready to travel. "The Eight," as the group was called, issued their declaration of independence, and in terms of good publicity it was a smashing success. Now there was a new antonym for "Academic." It was "Independent."

While Bellows was recuperating in Columbus, a jury at the Pennsylvania Academy of the Fine Arts selected *Forty-Two Kids* to receive the $300 Lippincott Prize, but a few hours later they decided for the sake of decorum to give the award to a different work. On hearing about this, Bellows cracked to the *New York Herald* that the problem was not the nudity: "It was the naked picture they feared."

The exhibition of The Eight had barely closed when the National Academy jury announced its latest decisions: all eight members had been admitted to the spring exhibition opening March 14. The Independents had prevailed, at least for now, and the *Times* ran a headline heralding "A New Spirit Seen at the Academy."

The same article singled out Bellows's *North River* (see pp. 42–43), calling it an "amazingly clever canvas." *Forty-Two Kids*, moreover, breezed through the jury process without incident. *North River*, a view across the Hudson toward the New Jersey Palisades, received the Academy's Second Hallgarten Prize, one of three awarded annually to American artists under the age of thirty-five for "meritorious oil paintings done in America." It was a timely choice, for the first of the new railroad tunnels under North River had just opened, speeding passengers from Sixth Avenue and Nineteenth Street to Hoboken in just ten minutes.

A few blocks from the Academy the high-spirited youngsters at the Art Students League celebrated Mardi Gras, 1908, with a display of "art works" by a group called the Society of American Fakers. Among the "masterpieces"

Forty-Two Kids
1907
Oil on canvas
42 × 60¼ in.
(106.7 × 153 cm)
Corcoran Gallery of Art, Washington, D.C.: Museum Purchase, William A. Clark Fund. 31.12

Both the critics and the general public had a great deal of fun with this famous East River scene when it first appeared. Some renamed it "Eighty-Four Legs," and others spent hours vainly trying to find all forty-two figures. James Huneker, the tough critic, wrote in the *New York Sun*: "Those 'Forty-Two Kids' . . . ought to move the heart of a grumpy schoolmaster. They are caught in the act, these boys, in forty-two different attitudes of youthful nudes, and rendered with nervous intensity. The humor, the humanity of that old wooden staging and its freight are unmistakable. A man who has such power in his elbow ought not to stop at the elbow."

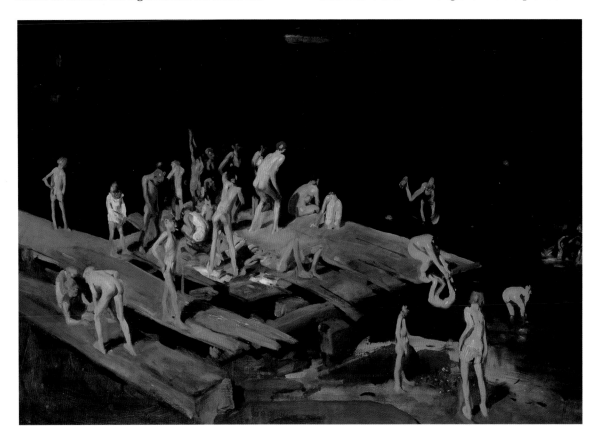

North River
1908
Oil on canvas
32⁷/₈ × 43 in.
(83.5 × 109.2 cm)
Pennsylvania Academy of the
Fine Arts, Philadelphia,
Pennsylvania: Joseph E. Temple
Fund. 1909.2
Courtesy of the Pennsylvania
Academy of the Fine Arts,
Philadelphia, Pennsylvania

Painted in February 1908, this
frosty view looks across the
Hudson River from Riverside
Park. A ferry, steaming out of its
slip, heads west into the path of
another vessel pointed south,
while a steam locomotive down
below makes its way through
the drifts.

on exhibit was a parody of *Forty-Two Kids* in which all the swimmers were under the water with only the soles of their feet showing on the surface. Bellows's response to this little prank is not recorded, but in all likelihood he enjoyed one of his big hearty laughs—especially since nearby there hung a takeoff on something by the great John Singer Sargent.

As summer approached, Bellows accepted a six-week teaching stint at the University of Virginia, and while there he painted a leafy view of the Charlottesville campus with clusters of students crisscrossing the greensward in front of Thomas Jefferson's stately buildings. Back in steaming New York, he headed to Coney Island to cool off and to study the sunbathers.

The Academy's winter exhibition included two Bellows canvases, a river scene and an unidentified portrait. Sloan, however, found the show disappointing: "It is an unusually bad collection this winter, and the prizes have been awarded in the most absurd way."

At the end of the year, Robert Henri parted company with the New York School of Art, having not received a paycheck from Chase's minions in several months. In making his announcement, he let it be known that a new Henri-led school would open soon. A hurried citywide search for appropriate classroom space led to some rooms on the sixth floor of the Lincoln Arcade on Broadway, just down the hall from Bellows's Studio 616.

Rain on the River
1908
Oil on canvas
32³/₈ × 38¹/₂ in.
(82.2 × 97.8 cm)
Museum of Art, Rhode Island
School of Design, Providence,
Rhode Island: Jesse Metcalf
Fund. 15.063
Photography by Erik Gould

As in *North River*, a little group of figures silhouetted at the river's edge provides a sense of scale, while the tall buildings of Manhattan hover in the distance, behind a veil of mist. This evocative "memory picture" was painted in the studio in December 1908.

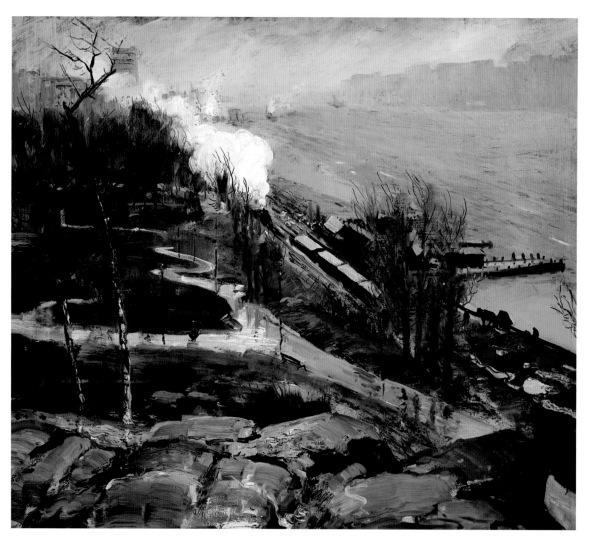

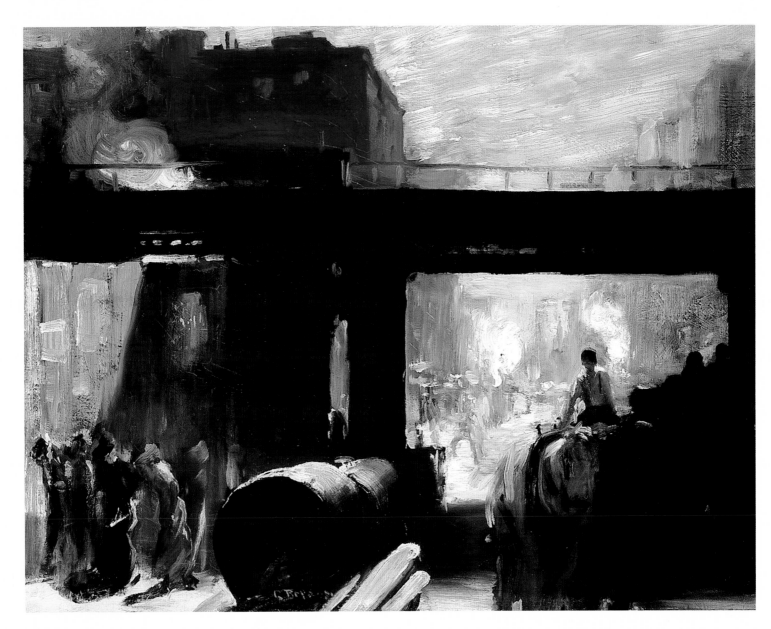

Noon
1908
Oil on canvas
22 × 28 in.
(55.9 × 71.1 cm)
Private collection, Washington, D.C.
Photograph courtesy of Keny
Galleries, Columbus, Ohio

On an overcast day in March, a
Third Avenue Elevated Railroad
train pauses above as a group of
passengers departs the street-level
exit. Beyond the trestle, yet
another big construction project
seems to be under way in New
York's never-ending effort to keep
up with the times.

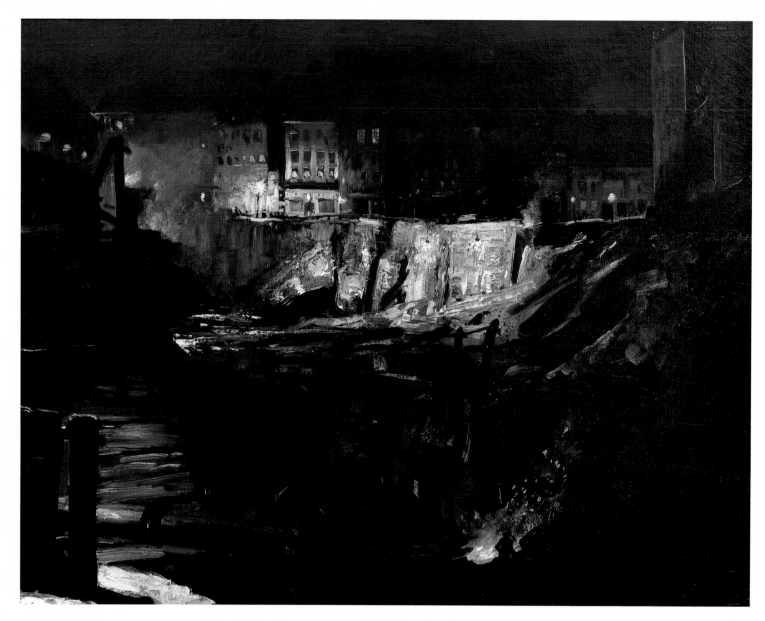

Excavation at Night
1908
Oil on canvas
34 × 44 in.
(86.4 × 111.8 cm)
Private collection

In December 1908, Bellows revisited the Pennsylvania Railroad's $25 million "hole in the ground" after dark. Both as an experiment in contrast and as an exhibition picture, the resulting painting succeeded handsomely. Bright spotlights illuminate the unfinished retaining walls while night-workers warm themselves by a crackling wood fire. Above, the mellow streetlamps provide a glimpse of small shops—soon to be replaced by upscale department stores—in the background. Meanwhile, visible just right of center, a mother pulls a reluctant child away from this fascinating but dangerous spot.

The Associate

The fifteen years I was a critic [1906–21] were a turbulent period in art. The critics' complacencies were constantly disturbed. The critics themselves staggered under a rain of blows for which they were completely unprepared and by which they were sometimes left in a stunned and helpless condition. Methodically acquired languages of critics were constantly being outdated. Stranger shapes succeeded strange ones. The critics' desks became littered with piles of art manifestations so new and numerous that, with the rush of the oncoming deadline, they got but a casual or wholesale analysis and tabulation.

Guy Pène du Bois, *Artists Say the Silliest Things*, 1940

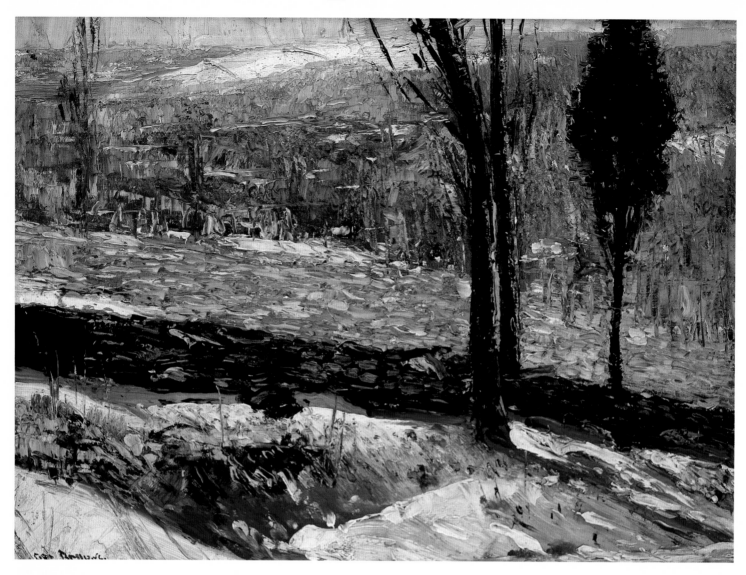

The Stone Fence
1909
Oil on canvas
18 × 24 in.
(45.7 × 61 cm)
Private collection

THE new Henri Art School opened on January 11, 1909, and most of his regular students came with him. Clearly things were getting off to a good start for The Boss.

It turned out to be a highly successful year for Bellows, too, but it did not begin auspiciously. For some time now one of the transients sleeping on Bellows's sofa (or floor) had been a friend of Ed Keefe's from New London, Connecticut. Eugene O'Neill, six years younger than George, had flunked out of Princeton's freshman class in the spring of 1908. His father, a well-known but nomadic actor in such plays as *The Count of Monte Cristo*, had promptly disowned him, and he had gravitated to New York in search of a "life experience." This he was financing by peddling junk jewelry from door to door.

Young as he was, O'Neill had earned quite a reputation for drinking and woman-chasing, and once Emma heard of this, she refused to be left alone with him under any circumstances. She may have preferred not to visit the studio at all as long as O'Neill was in town, so when O'Neill, Keefe, and Bellows decided to take a five-week winter vacation together she apparently raised no objection.

Their destination was an uninhabited, unheated old farmhouse in the Sourland Hills of western New Jersey, belonging to O'Neill's family. It was drafty, poorly lighted, and in need of maintenance. In her letters to George, Emma took to calling it "Decadence Manor." O'Neill spent much of his time next to the woodstove writing poetry, while Bellows and Keefe braved the wind and snow with sketchbook and easel in quest of the beauty in unlikely places that

Pennsylvania Station Excavation
Circa 1907–08
Oil on canvas
31³/₁₆ × 38¹/₄ in.
(79.2 × 97.2 cm)
Brooklyn Museum, Brooklyn, New York: A. Augustus Healy Fund. 67.205.1

Within the colossal retaining walls, work on the site continued around the clock, month after month, year after year, from 1903 until 1910. Bellows, like many New Yorkers, enjoyed playing sidewalk superintendent from time to time, mentally measuring its progress against that of the Panama Canal. On this chilly day in 1909, steam-powered earth-diggers and rock-blasters eat into Manhattan's substrata to make room for underground tracks.

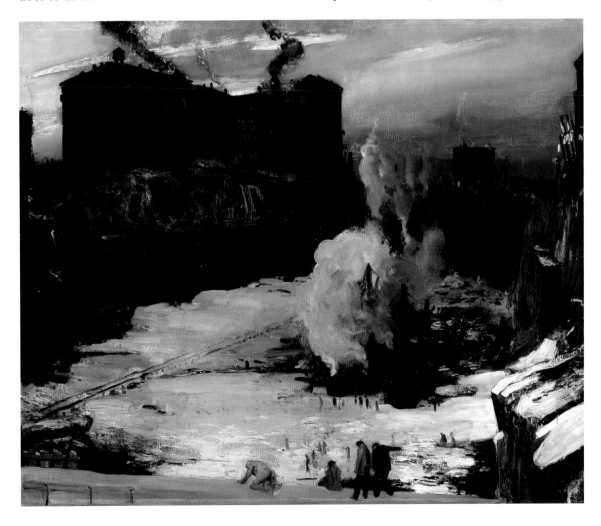

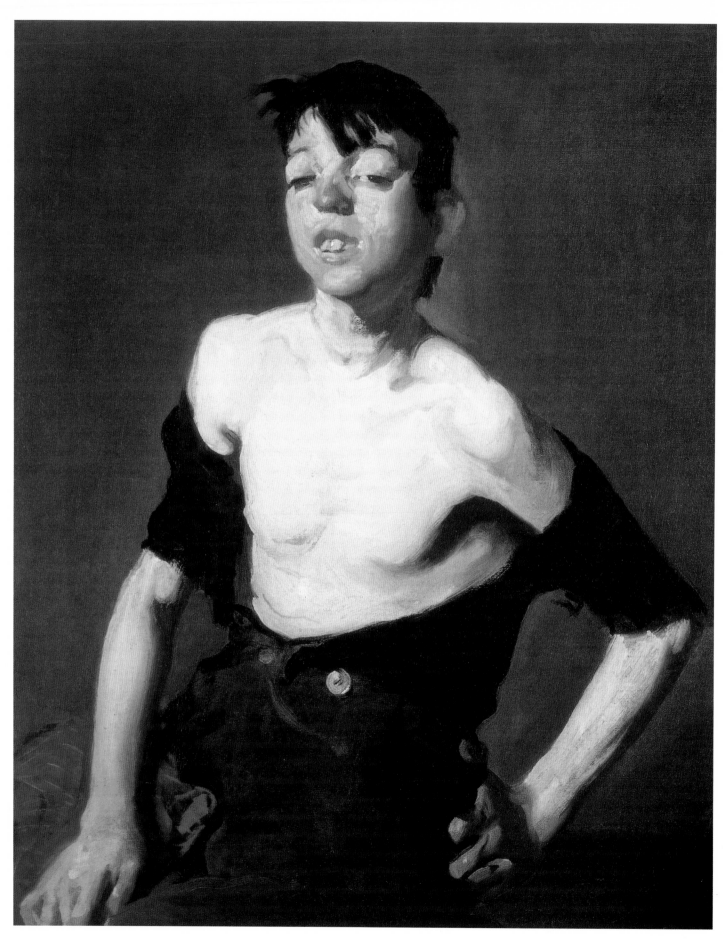

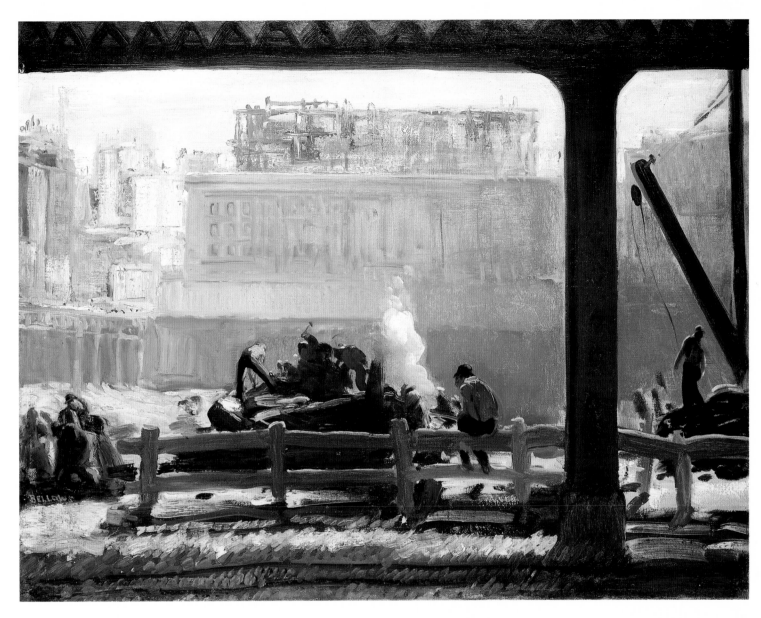

Blue Morning
1909
Oil on canvas
31⁵/₈ × 43³/₈ in.
(80.3 × 110.2 cm)
National Gallery of Art,
Washington, D.C.: Chester Dale
collection 1963.10.82.(1746)/PA
Image © 2006 Board of
Trustees, National Gallery of
Art, Washington, D.C.

As popular short-story writer
O. Henry put it, "New York will
be a great place if they ever
finish it." *Blue Morning* seems
to echo this thought, alluding to
at least two major construction
projects on one single downtown
block. Many of the workers
providing the labor to "finish it"
were part of the great influx of
immigrants to the city.

Paddy Flannigan
1908
Oil on canvas
30¹/₄ × 25¹/₄ in.
(76.8 × 64.1 cm)
Erving and Joyce Wolf collection
Courtesy of Hirschl & Adler
Galleries, Inc.

51

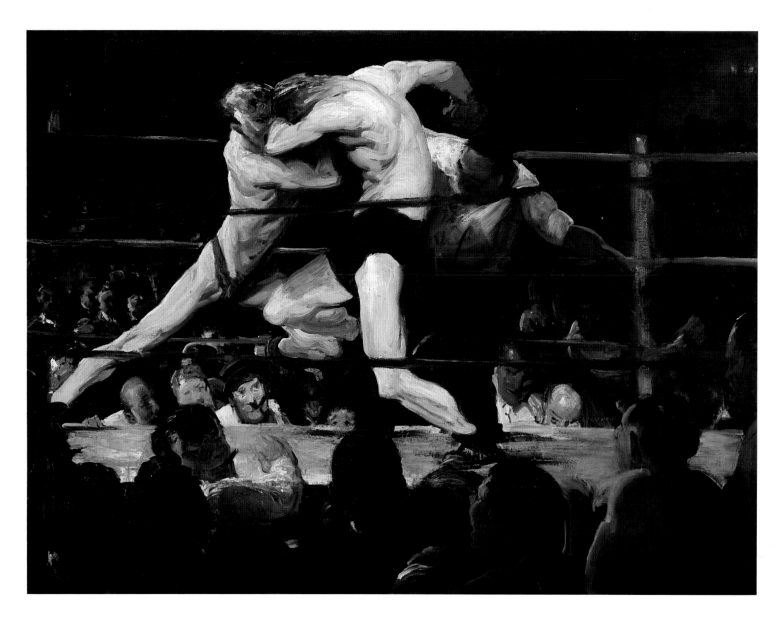

Carl Sandburg liked so much. Some fine work
was accomplished by Bellows during this
no-frills 1909 vacation: *Winter in Zion, Jersey
Hills, The Stone Fence* (see p. 48), *Fog and
Waterfall, Clouds and Hills*, and *Jersey Woods*.

O'Neill spent the next few years
experiencing life as an able-bodied seaman,
then settled down and became a very serious
playwright. George and Emma resumed their
evening rounds of theater-going and socializing
while he spent the lengthening spring days of
1909 at the easel, completing nearly twenty
canvases before year's end. In March, in
exchange for $250, *North River* (see pp. 42–43)
became part of the permanent collection of the

Pennsylvania Academy of the Fine Arts:
Bellows's first sale to a museum. In addition,
he was chosen to be one of the "representative
American artists" whose work was sent to the
Venice International Exposition.

On March 13 the National Academy's spring
exhibition opened, and, of the 275 paintings
admitted, two were by Bellows. One was the
lyrical *Rain on the River* (see p. 44), and the
other was a portrait called *Paddy Flannigan*
(see p. 50), which, in the eyes of some critics
flouted all the sacred laws of aesthetics. They
found it neither "beautiful" nor "inspiring."
One of the least derogatory remarks came in a
review in *The Nation* by Joseph E. Chamberlin,

who called the urchin "a pearl of the gutter." On the other hand, to the artist's independent-minded friends the painting embodied the spirit of American realism at its purest.

Just as the exhibition was about to close, Bellows received word on April 16 from Henry Watrous, secretary of the Academy, that he had been elected into that highly selective society as an Associate. If he wished to, though he never did, he could now sign his name "George Bellows, ANA." Better yet, he could raise his prices. He yearned to marry Emma Story some day, and his prospects were beginning to look a good deal brighter. Though he never did embrace the entrenched establishment, he did enjoy his celebrity for being, at twenty-six, one of the youngest artists to receive this honor in the Academy's eighty-three-year history. (The landscape painter Frederic E. Church was the youngest, at twenty-two.)

Almost overnight, his social circle became wider: Cecilia Beaux, the noted portrayer of New York aristocrats, invited him to her studio several times during the spring for private lessons in portraiture, and he and Emma were now included in the Thursday evening gatherings at the Petitpas sisters' boarding house, which were presided over by John Butler Yeats, the Irish poet's father. These were always enjoyable occasions, when members of The Eight and other upstarts could speak their minds openly about art, literature, and politics. Conversations around the tables were often so stimulating that after dinner the entire group would adjourn to Henri's house for more coffee and further discourse far into the night.

During the summer of 1909, Bellows helped Everett Shinn with his current project: decorating the elegant Belasco Theatre with murals. In August, he finished the second of his six prizefight paintings and a meditative landscape, *Summer Night, Riverside Drive*. He returned to the West Side in late September to witness the citywide celebration of two great

Summer Night, Riverside Drive
1909
Oil on canvas
35½ × 47½ in.
(90.2 × 120.7 cm)
Columbus Museum of Art, Columbus, Ohio: Bequest of Frederick W. Schumacher.
[57]1937.024

Bellows painted at least twenty New Yorkers in this magical view of a quiet evening in Riverside Park, but they are hard to find in the semi-darkness. Under the gas lamps are strollers and dog-walkers, and couples cuddling on the benches. A small crowd gathers around a bonfire at left, and more pedestrians enjoy distant fireworks from the river's edge below.

***The Bridge, Blackwell's
Island***
1909
Oil on canvas
34¹/₁₆ × 44¹/₁₆ in.
(86.5 × 111.9 cm)
Toledo Museum of Art, Toledo,
Ohio: Gift of Edward Drummond
Libbey. 1912.506

events in New York history: the hundredth
anniversary of Robert Fulton's pioneering
steamship trip upriver in the *Clermont* and the
three-hundredth anniversary of the arrival of
Henry Hudson's *Half-Moon* in New York Bay.
The US naval fleet was on hand, too, having just
returned from its around-the-world cruise.
Crowds flocked to the river front to watch the
spectacular pageant, and of course Bellows
could not resist such an opportunity. *Warships
on the Hudson* was the result.

By now the architectural firm McKim, Mead,
and White's huge Neo-classical Pennsylvania
Station was close to completion—it would open
to passengers on September 8, 1910—and
Bellows began looking elsewhere for a new
engineering marvel to commemorate. A brisk
walk across the island from Studio 616 took
him to the mile-and-a-quarter-long Queensboro
Bridge many times during November and
December 1909. As an errand boy on his father's
construction sites, Bellows had formed a deep
respect for soundly built structures designed
for both beauty and permanence. Nowhere
is this preference more evident than in *The
Bridge, Blackwell's Island*. A smaller
companion piece executed at the same time,
but in a sharply different mood, was *Lone
Tenement* (overleaf).

At the end of the year his contributions
to the Academy's winter exhibition were
Excavation at Night (see p. 46), which he had
shown earlier in the year at the Pennsylvania
Academy, and *The Palisades*, a winter scene
painted just after his frigid vacation in Zion,
New Jersey.

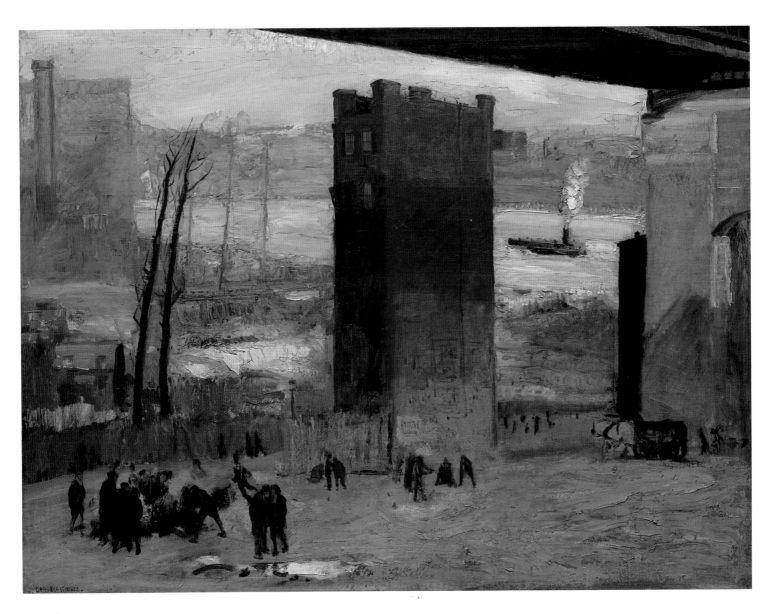

Lone Tenement
1909
Oil on canvas
36¹/₈ × 38¹/₈ in.
(91.8 × 96.8 cm)
National Gallery of Art,
Washington, D.C.: Chester Dale
collection 1963.10.83.(1747)/PA
Image © 2006 Board of
Trustees, National Gallery of
Art, Washington, D.C.

The Penn Station excavation
entailed the demolition of some
four hundred structures.
Downtown, in the shadow of
the new Queensboro bridge to
Blackwell's Island, only one
remains, alone and adrift in
what was once a populous
neighborhood. Bellows later
wrote that this picture had
"always been one of my favorite
canvasses . . . a large sunny
picture and me at my best."

The Bridegroom

*I have been working night and day on the hanging committee
of the Independent Exhibition. Such a Salon has been long in
the wind. The groans which arise after every Academy
Exhibition resulted in a definite undertaking this time.*

*There are two kinds of pictures which fail to "get across"
at the Academy. Those which are too bad and those which are
too good. There are many kinds of things which can be
classed as too good. Things that have more merit than the
worst picture actually hung. . . . Then there is a strange
disease in people's minds which makes them imagine
themselves as arbiters of beauty, and creates a constant and
foolish demand that pictures be all "pretty." As if Shakespeare
had always gone around writing love sonnets.*

George Bellows to Professor Joseph R. Taylor, April 20, 1910

Floating Ice
1910
Oil on canvas
45 × 63 in.
(114.3 × 160 cm)
Whitney Museum of American
Art, New York: Gift of Gertrude
Vanderbilt Whitney. 31.96

Returning to Riverside Park on
a January day in 1910, Bellows
saw ice moving on the water—
not a common event. Before his
eyes the ice was melting, but he
captured the floating shimmer
with his swift strokes. He
further embellished the scene
with small indications of life:
the birds on and around the
bench, a twosome approaching
a sailboat below, and on the
opposite side of the river tiny
black dots suggesting skaters
and sledders at play.

BELLOWS completed few new paintings in 1910.
For most of the year, he was indeed working
night and day on one major enterprise after
another, as he wrote Professor Taylor, from
late winter until the end of September. The first
marked a significant turning point in the annals
of American art, and the last brought about a
significant change in Bellows's own lifestyle.

Although there was little studio time this
year, his previous productions were steadily
making the rounds. *Morning Snow*, shown at
the Carnegie International in Pittsburgh, went
into the collection of German businessman and
philanthropist Hugo Reisinger in February for
an unprecedented $500—more than $10,000
today—and was subsequently exhibited in
Munich and Berlin. In March, a summer scene

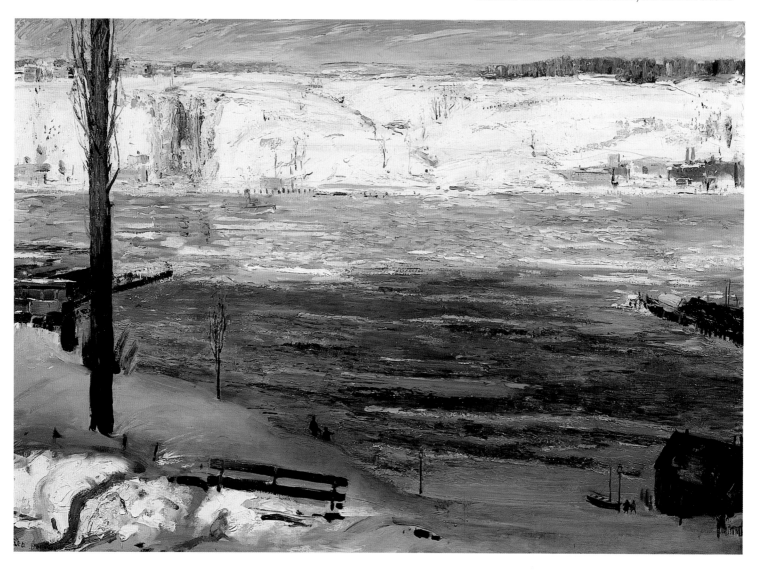

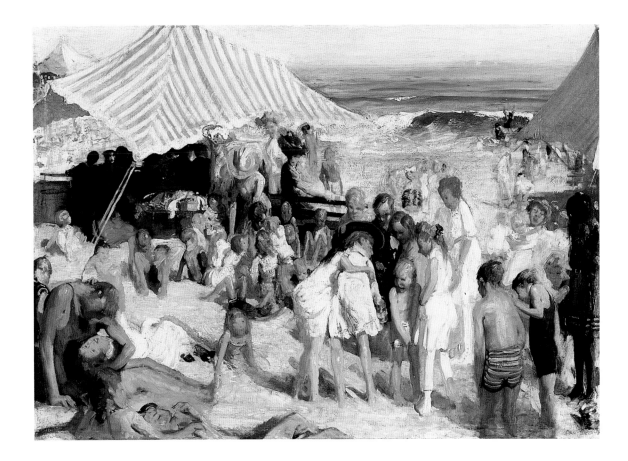

Beach at Coney Island
1908–10
Oil on canvas
42 × 60 in.
(106.7 × 152.4 cm)
Private collection
Courtesy of H.V. Allison & Co.,
Larchmont, New York

Bellows began work on this canvas in the summer of 1908, but did not finish it until two years later.

begun in 1908, *Beach at Coney Island*, was chosen by the National Academy exhibition jury, along with *Floating Ice*.

In the meantime, Bellows and many of his fellow artists were deeply preoccupied with plans and preparations for offering New York what, in John Sloan's words, promised to be "such an exhibition of American art as has never been seen before. The best exhibition ever held on this continent."

Late in January, the organizers leased a cavernous three-story warehouse on West Thirty-fifth Street, and Henri's pupils were put to work on the necessary task of cleaning the place up, while Bellows and his associates refurbished and painted the woodwork, built partitions, and masked the ugly walls in gray linen. Finally, when the time arrived, he worked on the all-important hanging committee.

The exhibition had a goal for which these artists were literally willing to work night and day: artistic freedom. "Freedom to think and to

show what you are thinking about," wrote Robert Henri in *Craftsman* magazine.

Freedom to study and experiment and to present the results of such an essay, not in any way being retarded by the standards which are the fashion of the day, and not to be exempted from public view because of such individuality or strangeness in the manner of expression . . . Every art exhibit should hear from the young as well as the old, and in this one we want to present the independent personal evidence which each artist has to make and which must become a record of their time and a proof of the advancement of human understanding.

Invitations were sent to a great many artists, asking them to participate, and promising "no rules, no jury, and no prizes." More than one hundred accepted with pleasure, and nearly five hundred drawings and paintings were duly

Polo at Lakewood
1910
Oil on canvas
45¼ × 63½ in.
(114.9 × 161.3 cm)
Columbus Museum of Art,
Columbus, Ohio: Columbus Art
Association Purchase. 1911.001

60

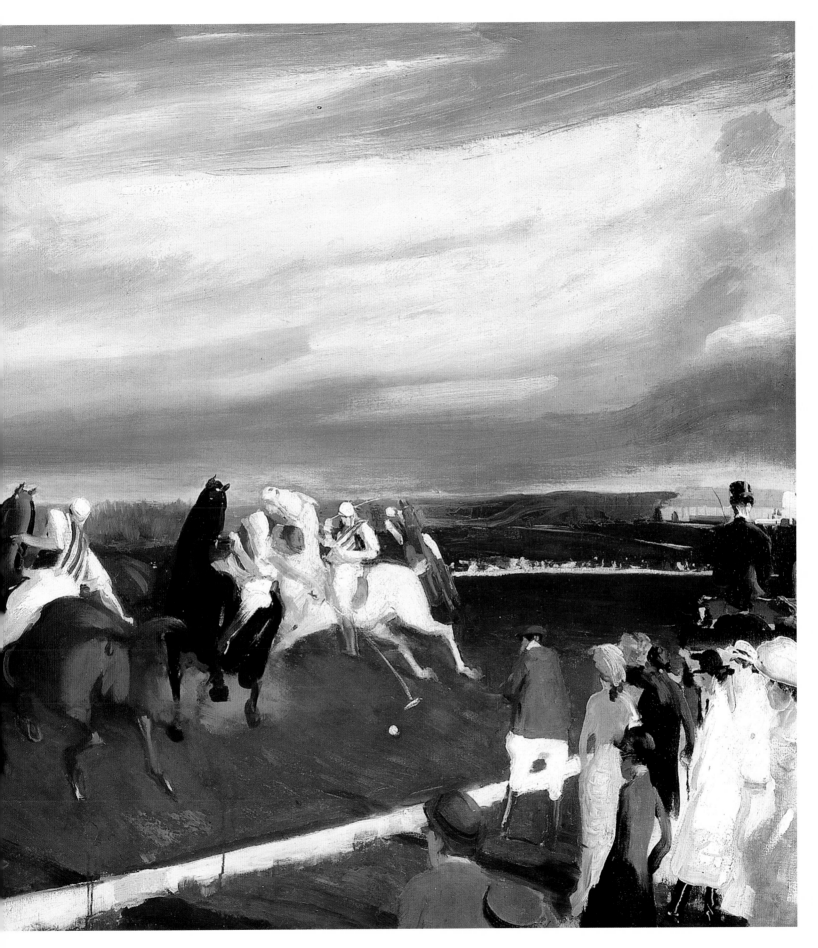

61

delivered to the redecorated warehouse. The works were hung where each one could be seen to best advantage. There was no "morgue" and none of the "skying" of pictures so dear to Academy juries.

Friday, April 1, the opening day of the Exhibition of Independent Artists, began with a private preview for art critics. That night, it was the public's turn. As described in John Sloan's diary, it was a "real triumph, the three large floors were crowded to suffocation, absolutely jammed at nine o'clock. The crowd packed the sidewalk outside waiting to get in. A small squad of police came on the run. It was terrible but wonderful to think that an art show could be so jammed. A great success seems to be assured."

The following day a headline in the *New York Mail* screamed "Panic Averted in Art Show Crowd," assuring a steady stream of visitors in weeks to come. The reviews, as expected, were mixed. Most critics appeared to be at a loss when confronted with so many unfamiliar names, so they tended to focus on the artists with whom they had dealt in years past: Henri, Sloan, Lawson, Shinn, Davies, Kent, and Bellows.

This response, of course, was just the kind Henri had hoped to discourage in his *Craftsman* article. An anonymous *Times* critic was one of the few who understood the fundamental message:

Certainly they have managed to fashion a most inspiring kind of romance out of the fabric of our contemporary local conditions and have got into their work the multitudinous aspect of our metropolis as none of their forerunners succeeded in doing. For this we should be grateful if they had done nothing else to further the so-called "cause" of American art. They have, however, done much more, and while a good deal of the work in the present exhibition is crude, the best of it demonstrates a healthy spirit and honest intention.

George Bellows's name appeared in the catalogue a dozen times, alongside his oil paintings *Club Night, Both Members of This Club, Blue Morning* (see p. 51), and *Fog and Waterfall*, and eight mixed-media drawings on paper. Overall, sales at the Exhibition of Independent Artists were only so-so, but three of Bellows's lively drawings were purchased by Joseph B. Thomas for a total of $500. Perhaps Rockwell Kent summarized the whole event best: "It was, for the first time in America, a democratic show."

Joseph Thomas, who bought the drawings, proffered Bellows an invitation, along with his bank check, to attend an upcoming polo tournament to be held in Ocean County, New Jersey, at the George Gould estate near Lakewood. Intrigued, Bellows found time to immerse himself in this hallowed sport of the very well-to-do. As usual, he proved to be an eagle-eyed spectator, missing almost nothing during the hours of fast-moving action. In his April 10 letter to Joe Taylor, he wrote:

Let me say that these ultra rich have got some nerve tucked away under the breast pocket. … It's an Aladdin's lamp sort of game. You wish to be a hundred yards to the left. You kick your heels and you're there. … The players are nice looking; the horses are beautiful. I believe they brush their teeth and bathe them in goat's milk. It's a great subject to draw, fortunately respectable.

Amid all the April turmoil, one day Bellows opened his mail and discovered that there was a job waiting for him in the fall at the Art Students League, teaching a life class and another in composition. The salary was modest

Shore House
1911
Oil on canvas
40 × 42 in.
(101.6 × 106.7 cm)
Private collection

Montauk Point is famous for its
lighthouse, long a beacon for
mariners heading to and from
Manhattan. Bellows sketched
this isolated spot during his
honeymoon and rendered it in
oils the following January.

Blue Snow, The Battery
1910
Oil on canvas
34 × 44 in.
(86.4 × 111.8 cm)
Columbus Museum of Art,
Columbus, Ohio: Museum
Purchase, Howald Fund.
1958.035

New Yorkers love to grouse
about snow and the filthy,
slushy aftermath of every
winter storm, but not George
Bellows. On this December
afternoon, he seized the
opportunity to sketch a foot
of pristine new-fallen snow in
Battery Park, on the southern
tip of Manhattan. The walks
have just been cleared, and
people are heading briskly to
and from the nearby ferry
terminals.

64

by today's standards, but, combined with the proceeds from his recent sales, he was ready to put the question to Emma Story. The two had enjoyed one another's company for nearly six years; he was solvent at present; and he adored her. Besides, he had an ace up his sleeve: Pa Bellows, knowing of his son's feelings for Emma, had promised to buy them a decent place to live in the event he married her. Very soon the couple began looking at real estate.

Together, they inspected several houses, finally opting for Emma's favorite, a charming Federal-style brick row-house at 146 East Nineteenth Street, just a block away from Gramercy Park. It had three stories and a cheery English basement, which they planned to rent out. The house was seventy-five years old, but George, an expert carpenter, could make most of the necessary improvements himself. Emma took an active part in planning the domestic renovations while her future husband spent the entire summer tearing up floors, installing cabinetry, and, with some professional assistance, raising the roof eight or ten feet to make space for a sort of mezzanine above the second-floor studio.

It was not until nearly all the work was finished that Emma broke months of suspense by announcing that she was ready to make plans for the wedding, which, she divulged, would occur on Friday, September 23. Because she was brought up as a Christian Scientist, Emma was not in favor of a formal, clergy-dominated ceremony, and because George tended to feel the same way, they settled on a simple exchange of vows with only Emma's parents and a few other witnesses present. They had a mutual friend who was chaplain at a small Episcopal parish in Williamsbridge, New York, out in the South Bronx, who readily understood the couple's wishes and agreed to officiate.

When the day arrived, George was so relaxed about the arrangements that he spent the morning in Studio 616, deeply absorbed in work. Suddenly, three hours before the ceremony, he realized that he did not know, or could not remember, exactly how to get to the chapel. A telephone call to the minister produced the necessary information, but the complicated subway-and-streetcar journey made him and most of the wedding party late for the ceremony.

After the brief wedding, the bride and groom hastened toward Sag Harbor to deliver the good news to Bellows's vacationing parents. His father, now in his eighties, was in poor health, and it had seemed best not to ask his parents to undertake such a tiring journey. The newlyweds spent part of the weekend in Montauk, on the easternmost tip of Long Island, made their joyful announcement, and headed straight back to Manhattan, to start married life in their new home.

Bellows won no significant prizes in 1910—he had been far too busy—but Emma was the Grand Prize all by herself: poised, pretty, witty, intelligent, talented, well bred, capable and competent, orderly, articulate, affectionate, and steadfast.

Chaos in Columbus

By independence in art is meant a freedom from tradition, with about the same latitude as anarchy may be defined as freedom from law. Consequently some of the independents are more independent than others. Some poor, weak brethren follow afar off, and so one may look at their pictures, may even know what they are intended to represent, and may catch an uplift and an inspiration from them. Others are so aggressively in the van of the movement that like a vanishing rider in a cloud of dust, it is left to the fancy and imagination, both to guess where he is going and why he is going, without any particular spur to induce the faculties of fancy and imagination to make that exertion.

"Paintings Show Great Latitude," ***Ohio State Journal***, **January 18, 1911**

FOR a long time now, Bellows had envisioned bringing a show of contemporary art to his hometown, where modern trends in American art were still generally unknown. In 1910, he approached the Columbus Art Association with this idea and was warmly received. Negotiations began at once with the trustees of the city's Carnegie Library for suitable exhibition space, but when Bellows insisted on incandescent illumination, instead of gaslight, the library backed out: it would cost too much.

Now that a year had passed, news of the Independent Artists' success in New York had reached Columbus, and the library was only too happy to house a similar, but smaller, display, properly lighted by electricity. An opening date was set, January 12, 1911, and as usual Bellows rolled up his sleeves and got down to work. In all, there were thirty-six artists to borrow works from, and 135 paintings to crate, ship, uncrate, hang, re-crate, and ship back to New York. Henri arranged the loans and even promised to come to Columbus midway through the exhibition to give a public lecture on "The Modern Movement in Art."

But January 12 came and went. There was no opening that day, or the next, or the next. Eventually a small-type item in the *Ohio State Journal* reported that, owing to a five-day postponement, the exhibition would be open on Tuesday evening, the 17th.

Unknown to the public, those missing five days were some of the most tumultuous in Bellows's entire life. The crates had all arrived in plenty of time, and the hanging was nearly finished as the scheduled opening date approached. But as fast as he could get the pictures arranged on the walls, they began to disappear—not all of them, but a significant number of those Bellows thought of most highly. When, in the strongest possible words, Bellows demanded an explanation, he learned that, working behind his back, a "committee" of library bigwigs had found the paintings in question "inappropriate" and "unsuitable."

Among the works deemed improper were George Bellows's *The Knock Out*—boxing was against the law in Ohio, so just looking at a picture of it was deemed inappropriate—four chastely diaphanous nudes by Arthur B. Davies, a landscape with fully naked men wrestling by Rockwell Kent, and a whole series of John Sloan's etchings.

Furious, Bellows threatened to cancel the whole show immediately, but the Art Association implored him not to. As a compromise of sorts, the self-appointed censors agreed to confine the offending pictures in a separate room, under lock and key, well guarded, and viewable only by gentlemen. As Sloan remarked in his diary, "Think of the vulgar indecency of ignorance!"

The remote chamber was quickly christened "The Men's Room," and everybody soon heard about it. A review on January 18 in the *Ohio State Journal* ended with this observation:

Oh yes, and then there is the extra room. In it are hung several pictures which the directors of the library would not permit to be hung in the main salon. To say that they are the best pictures of the entire collection, would be to submit one's judgment to serious misconception, yet those who saw them last evening were generally of that opinion. These are pictures, for the most part, where the artist, feeling at least for a moment the enkindling spark of passion, has tipped his brush with some semblance of fire, and conveyed to the eye, not figures but feelings, not thoughts, but emotions. If these be independent, they are independent in a different manner than those which hang in the larger room. They suggest strongly the French struggle after an ideal of beauty, as that is exemplified in the human form.

As promised, Henri showed up for his lecture, although he was still fuming about the fiasco at the library. His first thought, like Bellows's, had been to pack up the crates, come home, and try to forget the whole incident, but in the end he decided that the best way to show his strong support of these artists was to explain to the public what the Independent movement was all about.

When Henri arrived in Columbus, there was a surprise awaiting him, too. Before taking the stage, he was handed a sheaf of scribbled notes that visitors had been dropping into a "question box" in the exhibition hall since opening day. Realizing that he was expected to answer all, or most, of these queries during the evening, he did his best. But, of course, the questions came in no particular order, so that there was little cohesion to his talk. Next morning a headline in the *Ohio State Journal* read "Auditors Held by Henri Two Hours."

Before the exhibition closed, the issue of public decency seemed to have spread all over Columbus. Two days into the Independent Artists show, the feisty anarchist Emma Goldman was slated to address a convention of the United Mine Workers on the subject of "Organized Labor." When she arrived at Memorial Hall, the county commissioners barred the door, having decided that Goldman was "not a proper person." She and some two hundred workers then marched to Red Lion Hall, where she took advantage of the occasion to throw some well-aimed darts at the commissioners for their refusal to permit free speech.

Then, on the 30th, as Bellows was preparing to ship the exhibition back to New York, the Reverend William Ashley "Billy" Sunday rode into town bringing an evangelical sermon for a law and order convention on the subject of "Booze." Chances are that the commissioners did not lock the doors of Memorial Hall that

time. (Later in life, Bellows would have some choice words to say about old Billy Sunday, and he became a steadfast supporter of Emma Goldman and especially her campaign against censorship.)

Other headlines in the *Ohio State Journal* during the ill-fated month of January 1911 included "Chicken Show Opened in Big Burst of Glory," referring to a jam-packed exhibition given by the Ohio State Poultry Association, and "Thousands Will Tender Homage to King Corn." And they used to say nothing ever went on in Columbus!

Just after George and Emma returned to the relative tranquility of Manhattan, the board of trustees of the Columbus Gallery of Fine Arts voted on February 3 to purchase *Polo at Lakewood* (see pp. 60–61) for "a sum not to exceed $1000." After Bellows deducted 10 percent for expenses, his net gain was $900, which in today's currency translates to $18,000—more than enough compensation for all the difficulties he had just been through.

There was much more work awaiting Bellows in New York, where his first real one-man show was under way at the avant-garde Madison Gallery, a modest selection of twenty-four pictures that attracted little attention in the press. But it did not matter, for his chief concern now was to get back to the studio and put finishing touches on his National Academy entries before the end of February.

One painting in particular had been taking shape for many months: an urban tour de force that he called simply *New York* (overleaf). In essence it was to be a distillation of his innumerable impressions of the city he now knew so well: a composite view of a busy midtown intersection on a winter day years before the invention, in the early 1920s, of automatic traffic lights. The setting contains elements of both Union Square and Madison Square during the rush hour, packed from curb

69

New York
1911
Oil on canvas
42 × 60 in.
(106.7 × 152.4 cm)
National Gallery of Art,
Washington, D.C.: Collection
of Mr. and Mrs. Paul Mellon
1986.72.1./PA
Image © 2006 Board of
Trustees, National Gallery
of Art, Washington, D.C.

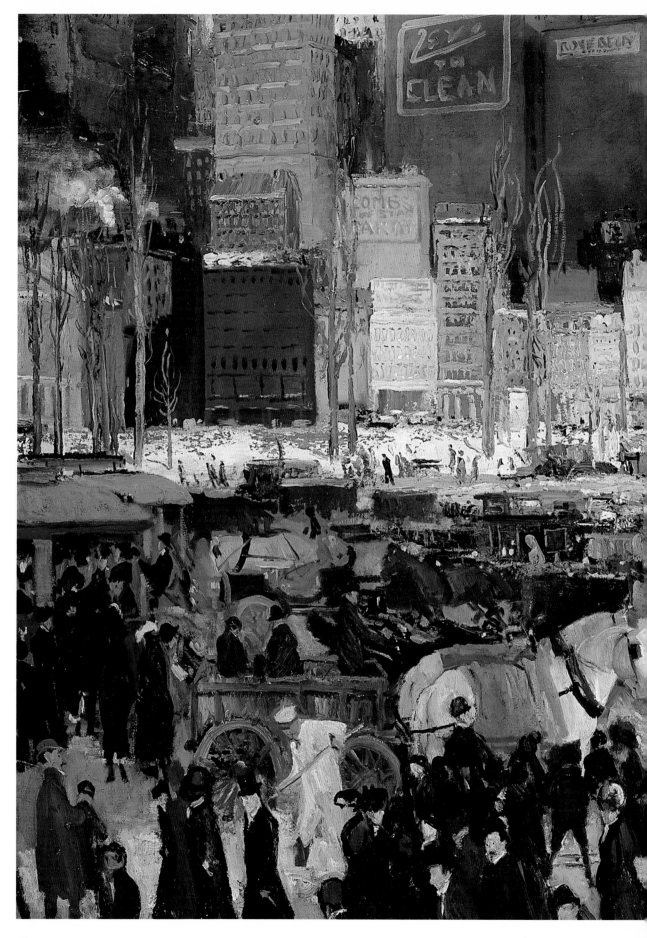

Robert Henri
American, 1865–1929
George Wesley Bellows
1911
Oil on canvas
32 × 25⅞ in.
(81.3 × 65.7 cm)
National Academy Museum,
New York. 561-P

Each newly elected Associate
of the National Academy of
Design must furnish an "artist
portrait" for the society's
collection. The tradition dates
back to 1839 and prevails today.
In 1911, shortly before his
twenty-ninth birthday, Bellows
persuaded Robert Henri, his
former teacher, to paint the
required head-and-shoulders
portrait.

to curb with horsecarts, trolleys, hansom cabs, and an enormous hay-wagon, touched by a stray sunbeam, all standing stock-still despite the efforts of a city policeman to get things moving. Only the pedestrians, heading for the shops and offices, are in motion, though far in the distance the Third Avenue "El" goes blithely on its way.

That this one-of-a-kind painting had actually received the blessing of the Academy jury appalled the critics for all the usual reasons, although on March 18, a gentleman from the *New York Times* warned that while it was "a picture to move a beauty loving observer to bleak despair . . . some day far in the future, it will be pointed out, no doubt, as the best description of the casual New York scene left by the reporters of the present day."

In April, Hugo Reisinger, the wealthy German collector, purchased Bellows's *Up the Hudson*, and, after exhibiting it abroad, he presented it, as he had promised to do, to the Metropolitan Museum of Art. Not yet thirty, Bellows now had paintings in three American museums: the Pennsylvania Academy of the Fine Arts, the Columbus Gallery of Fine Arts, and the Metropolitan Museum of Art.

As summer approached, Emma's parents urged George and Emma to stay with them in Upper Montclair, for Emma was expecting a child in September and would need a lot of rest and parental support to get her through the home delivery ahead. At the time it seemed to be a good idea, but George soon realized that, except for tennis at the country club, there was nothing fun to do there. For once in his life, he was bored to distraction. Then, some time in late June, he received a letter from the Henris, postmarked "Monhegan, Maine."

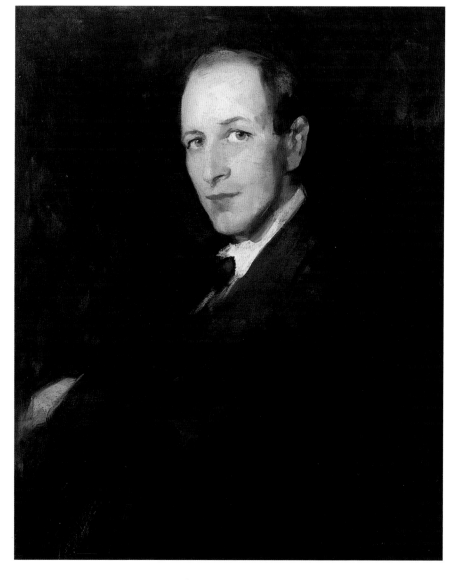

Down East

Monhegan: its rock-bound shores, its towering headlands, the thundering surf with gleaming crests and emerald eddies, its forest and its flowering meadowlands; the villages, quaint and picturesque; the fish-houses, evoking in their dilapidation those sad thoughts on the passage of time and the transitoriness of all things human so dear to the artistic soul; and the people: those hardy fisherfolk, those men garbed in their sea boots and their black or yellow oilskins, those horny-handed sons of toil—shall I go on? No, that's enough. It was enough for me, enough for all of my fellow artists, for all of us who sought "material" for art. It was enough to start me off to such a feverish activity in painting as I had never known.

Rockwell Kent, *It's Me O Lord*, 1955

RATHER than spend another strenuous summer in Europe, Henri and his wife, Marjorie, opted in 1911 for the Maine coast instead. On earlier visits The Boss had fallen in love with Monhegan Island, and it was on his recommendation that Rockwell Kent, as a young man, had spent two years there. Now the gregarious Henri was getting up a small house party: Randall Davey, one of his pupils, was coming, and he invited Bellows to join them.

Emma, who could already read her husband's mind, knew how restless he felt, confined in that little New Jersey house with so much time on his hands. The baby was not due before the end of August, and in the meantime there was little he could do for her. She would be much happier knowing that he was exploring, painting, and savoring the salt air of the Atlantic. She could always go there with him some other time. So it was decided and, not without a twinge of guilt, he finally accepted the invitation. By late July, George was showering her with letters, postcards, and sketches depicting the wonderful vantage points he had discovered, his only complaint being, "My head is full of millions of great pictures which I will never have time to paint."

The three artists spent long days tramping the old dirt trails from destination to destination: Deadman's Cove, Washerwoman

An Island in the Sea
1911
Oil on canvas
34¹⁄₄ × 44³⁄₈ in.
(87 × 112.7 cm)
Columbus Museum of Art, Columbus, Ohio: Gift of Howard B. Monett. 1952.025

From Maine, George reported in a letter to Emma that this canvas was "a real sure enough masterpiece"—the rocky islet off Monhegan, called Manana, as seen on a foggy morning.

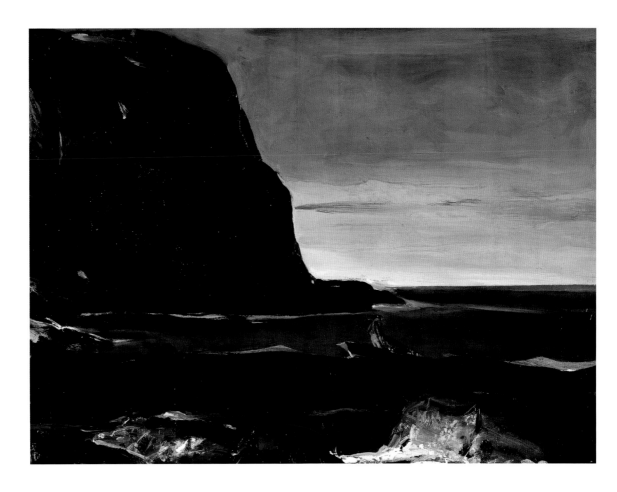

Rock, Norman's Ledge, Pulpit Rock, and
Cathedral Forest among them. And around
five o'clock there was usually an impromptu
village softball game out near the Monhegan
lighthouse, where the meadow was fairly level,
and where Bellows enjoyed himself immensely.

More than ten miles out to sea, on a rocky
island occupied only by fishermen's families,
herring gulls, a handful of "summer folks," and
some barnyard animals, and where daily life
revolved around the tides, the weather, and
the migratory patterns of cod and mackerel,
Bellows was in his element.

In just a few weeks he accumulated more
than fifty paintings, some on canvas but most
on easily portable artist-board panels seldom
larger than 18 by 22 inches—to say nothing of
all the sketches and mental images he could
turn to later on. On September 1, Bellows
headed back to Upper Montclair, proud of
the many "beauts" and "dandies" he had been

crowing about in his letters to Emma, and
just about as ready as he would ever be to
become a father.

Days dragged by, and still the infant did not
appear, but everyone agreed it would be a
boy—in fact, they had already named him John.
Then, on September 8, 1911, "John" finally
joined the Bellows family: a healthy little girl.
From that moment on, they called her Anne,
after her paternal grandmother, Anna Smith
Bellows. As soon as mother and child could
travel, all three returned to their own home in
New York, where at last Bellows could unpack
his sun-faded clothes and shake the last grains
of sand out of his shoes.

All in all, 1911 had gone well for George
Bellows. Throughout the year, his paintings
had been constantly on the move: at one time
or another, they could be seen in Chicago,
Detroit, Cincinnati, New Orleans, Philadelphia,
Pittsburgh, Toledo, Washington, D.C.,

75

Snow Dumpers
1911
Oil on canvas
36¹/₈ × 48¹/₈ in.
(91.8 × 122.3 cm)
Columbus Museum of Art,
Columbus, Ohio: Museum
Purchase, Howald Fund.
1941.001

In December 1911, Bellows
observed a group of uniformed
city employees supervising a
crew of day-laborers as they
shoveled tons of overnight
snow into the East River.
Below the Brooklyn Bridge,
tugboats steamed past
purposefully in the early
morning darkness. "No pitying
socialistic note spoils his virile
art," wrote James Huneker in
Harper's Weekly. "His workmen
are the average workmen of
everyday existence. Labor is
not precisely sacred, nor is it
precisely a curse. It just
happens, for mankind must
eat, and in the sweat of his
brow, Bellows shows the
working-man as he is."

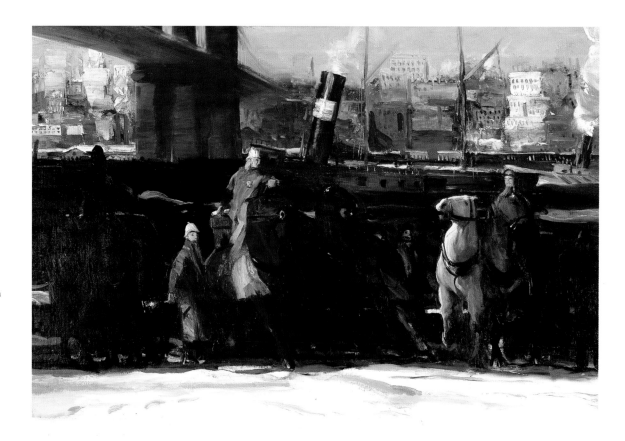

Worcester, Massachusetts, and, of course,
New York City.

At the end of the year, Bellows found
himself on yet another planning committee
bent on bringing more new art to the public.
As before, the main objective was to bypass the
entrenched jury system. But this time a very
different kind of rebellion was in the air, and
the people proposing it were, for the most part,
already well established and confident in their
own careers. Few of the founders were known
to have revolutionary leanings; most, like
George Bellows, were tolerated, even admired,
by both academicians and freethinkers. As the
constitution drawn up by the Association of
American Painters and Sculptors noted: "How
to exhibit and protect the producer against the
indefinable tyranny every institution sooner or
later exerts is our great problem. That is the one
thing we mean to solve, if it can be done."

Cautiously, they chose as their president
Arthur B. Davies, a man who had always
painted in his own mysterious way, with a
timeless dignity that seemed to rise above the
trends of the moment. He sought no publicity
—in fact he seemed to shrink from it—and no
critic would dream of calling him an "apostle of
ugliness" or "brutal butcher of beauty," phrases
with which the men of Henri's circle were only
too familiar.

On the whole, as *Harper's Weekly*
summarized: "It is the esprit de corps that is a
precious part of the new association …
[meeting] more than half-way the swelling tide
of the life of our own time and interpreting and
helping to guide its manifestations." Fourteen
months later, from this modest, almost
tentative, beginning arose the most explosive
art exhibition ever before experienced in New
York: the Armory Show. And few, if any, of the
men present at that meeting—certainly not
George Bellows—saw it coming.

The "Little Renaissance"

I have been called a revolutionist—if I am, I don't know it. First of all, I am a painter, and a painter gets hold of life— gets hold of something real, of many real things. That makes him think, and if he thinks out loud he is called a revolutionist. I guess that is about the size of it.

George Bellows, "The Big Idea," *Touchstone*, July 1, 1917

B Y 1912, New York, now recovering from a five-year economic recession, was experiencing a fresh burst of energy in all the arts: experimental modern drama on the Broadway and Little Theatre stages; new, often discordant, music in the concert halls; realistic new fiction in the bookstores; and the exuberant barefoot choreography of Isadora Duncan, who had been performing in the city for several years. Such innovations, along with the moving pictures, the flying machine, the motorcar, and the snappy ragtime beat, with new dance steps to go with it, all added up to a golden, but all too brief, age of free inquiry and exploration.

Bellows's friends, the artists and intellectuals who frequented the Petitpas boarding house, applauded this change in climate. Bellows himself devoured the new literature, escorted Emma to as many plays and concerts as he could afford, and learned to love ragtime. At the drop of a hat he would belt out his current favorite, "Nero, My Dog, Has Fleas," a syncopated, and blasphemous, version of "Nearer, My God, to Thee."

He also read with great interest the early issues of *The Masses*, then a sophisticated, vaguely socialist monthly just coming into its own after a shaky start. Not since the days of political cartoonist Thomas Nast had New York seen such powerful satire in graphic form. Max Eastman, the editor, prepared, at the suggestion of radical journalist John Reed, a manifesto of sorts, which appeared in the February 1913 issue, just before Bellows submitted his first drawing:

The Magazine is Owned and Published Cooperatively by its Editors. It has no Dividends to Pay, and nobody is trying to make Money out of it. A Revolutionary and Reform Magazine; a Magazine with a Sense of Humor and no respect for the Respectable; Frank; Arrogant; Impertinent; Searching for
True Causes; a Magazine Directed against Rigidity and Dogma wherever it is found; Printing what is too Naked or True for a Money-Making Press; a Magazine whose final Policy is to do as it Pleases—A Free Magazine.

Quite apart from its partisan overtones, this document provides a keen insight into George Bellows, the artist and the man. He was well known for his own sense of humor, his frankness, his occasional arrogance and impertinence, his steadfast opposition to rigidity and dogma, and especially for doing "as he pleased" in art.

Certainly he was no bomb-thrower, even though some hostile art critics persisted in calling him an "anarchist." Nor was he by any definition a conservative. Friends and acquaintances recalled that he usually kept his political opinions to himself, preferring actions to words. On May 4, for example, he joined his wife, an ardent feminist, in a massive but peaceful demonstration in favor of women's rights, marching up Fifth Avenue alongside John and Dolly Sloan and more than ten thousand others.

Bellows did not confine his magazine assignments to radical publications. The May issue of *Collier's* carried three of Bellows's drawings, and over the next few years, he supplied illustrations for a number of stories and articles that appeared in the *American Magazine*, the *Century*, the *Delineator*, *Harper's*, *Hearst's International Magazine*, and *Everybody's Magazine*, as well as many in *The Masses*. These assignments provided a lucrative sideline and a welcome return to his first love: the simple spectrum of black and white, and the myriad gradations and nuances in between.

Although in 1912 Bellows's canvases traveled to exhibitions in at least eight states, the majority dated back to 1911 and even

Explosion in the Armory

Here was a real quandary. Here was a large group of cryptograms for which there was no key. Here was something about which all the reference books, catalogues raisonnés, even the newest volumes in the fullest and most complete libraries could do nothing. Here was a manifestation which could not even be attacked upon a moral ground. But if the critics were flabbergasted, so were the artists.

Guy Pène du Bois, *Artists Say the Silliest Things*, 1940

GEORGE Bellows never went to Europe, as Henri, Chase, and almost all of his artist friends had done as a matter of course. His one departure from the land of his birth consisted of stepping across the Canadian border and back on a spur-of-the-moment excursion to Niagara Falls.

He was perfectly content, he often said, to chronicle the American people, their lives, and their landscapes. As a result, he was utterly unprepared for the first and, as it turned out, the only exhibition of the Association of American Painters and Sculptors. He had been among the twenty-five founding members back in December 1911, when it was generally agreed by all that AAPS exhibitions should be international in scope, like those held annually at the Carnegie Institute in Pittsburgh.

Now that easier transatlantic travel was making the world smaller, the sponsors believed the American public should take a closer look at other cultures, and vice versa. What few of the founders knew, or even suspected, was that by 1913 the Old World was far ahead of New York where art was concerned—so far advanced, in fact, that even such courageous American realists as Henri, Luks, Glackens, and Bellows were bound to seem old-fashioned in comparison. The new freedom they had defended so stoutly for more than a decade might amount to very little, after all, in the global scheme of things.

By the time Bellows returned from Columbus in January 1913, hundreds of artworks had already arrived from Paris. Even the most progressive members were shocked and dismayed by what they saw, and it was far too late now to cancel what might well turn out to be a debacle. As one of the sponsors and founders of the Association, Bellows was expected to make miracles happen. The most urgent task facing the executive committee, including Bellows, was to transform the vast,

dimly lit fortress on Lexington Avenue known as the Sixty-ninth Regiment National Guard Armory into a respectable art gallery. Partitions had to be created—enough to accommodate up to 1500 objects, more than two-thirds of them American and the remainder from Europe. Illumination was a high priority, too, and there was the little problem of deploying all those paintings and sculptures advantageously while keeping in mind the large crowds anticipated.

Bellows and his fellow executives came up with an ingenious solution to the display problem: a honeycomb-like arrangement of interconnecting chambers erected in such a way that both sides of each burlap-covered wall could be hung with pictures. Wide aisles would provide plenty of space for sculptures and room for the easy flow of visitors.

Best of all, the wall panels and benches and plinths could all be prefabricated elsewhere, for the Association's short-term lease on the Armory was perilously brief, effective only from February 10 through March 20. This meant that Bellows and his crew had just five days and four nights in which to set up everything for the press review on February 14: seventy-two hours to install the entire honeycomb and string up the lights, and forty-eight hours to deploy all the works of art.

As soon as the show opened to the public the following Monday, the Reception and Publicity Committee sprang into action, requiring Bellows and others to station themselves at a desk near the entrance, greeting visitors, escorting them, if need be, through the exhibition, and attempting to answer any and all questions, no matter how bizarre.

His friend Randall Davey later recalled that a very frequently asked question was "which way is the most expensive picture?" The wide-awake young artists at the desk, said Davey, "took turns taking these visitors to our own pictures and giving them a real fancy price."

Probably the most famous guest to take the guided tour was Theodore Roosevelt, who was escorted through the maze by Arthur B. Davies himself. The ex-president was heard to shout, "That's not art!" whenever confronted with a work by Pablo Picasso, Georges Braque, or Constantin Brancusi. Finally, they reached Marcel Duchamp's *Nude Descending a Staircase*. Bellows had hung it in a conspicuous place near the exit, where the thickest crowds tended to gather. "Where's that woman?" demanded TR. When Davies tried to respond, he was interrupted by another snort: "He is nuts, and his imagination has gone wild!"

As for Bellows, he rather enjoyed Duchamp's playfulness, and Cubism in general intrigued him with its elusive internal logic. When asked, he hinted that he hoped to investigate it further. "It may or may not be valuable," he said. But he reserved his greatest enthusiasm for Renoir, of all the Europeans. Victor Salvatore, then a young sculptor, still remembered, fifty years after the event, that "when George Wesley Bellows saw for the first time the painting of Pierre-Auguste Renoir, he was thrilled and praised his work to artists and art dealers. I feel very strongly that the success of Renoir's painting in this country is due to George Bellows." And also, it should be added, due to the art dealer Durand-Ruel and Sons, of Paris and New York, who handled all four of the Armory Renoirs.

Saturday, March 15, 1913, was the last day of the Armory Show, and half of New York seemed to drop by for a last look. It was also the opening day of the National Academy's Eighty-eighth Annual Exhibition. The seeming coincidence was no accident; the modernists had planned it that way, as a subtle reminder to the Academy that, although the rebellious European works were leaving New York en route to the Art Institute of Chicago, the New Spirit was there to stay.

A Day in June
1913
Oil on canvas
42 × 48 in.
(106.7 × 121.9 cm)
The Detroit Institute of Arts,
Detroit, Michigan: Detroit
Museum of Art Purchase, Lizzie
Merrill Palmer Fund. 17.17
Photograph © 1991 The Detroit
Institute of Arts

Based on an earlier drawing
called *Luncheon in the Park*,
this view is filled with
fashionably dressed ladies,
gentlemen, and children at
leisure in the shady glens of
Central Park. *A Day in June*
went on to win the 1917 Temple
Medal at the Pennsylvania
Academy of the Fine Arts.

All in all, as modernist William Zorach put it, the International Exhibition of Modern Art

was a tremendous sensation and reached all kinds of people as well as artists … the crowds piled in and out day after day—some hilarious—some furious—none indifferent. There was never anything like it—so completely a surprise—so completely devastating to the complaisant American. But still the revolution was very slow in taking effect—it was a good forty years before it took over and became the new Academy.

There is a certain irony in the fact that just as the last Armory visitors were departing,

the National Academy awarded Bellows the first prize in its annual Hallgarten competition and $300 for *Little Girl in White*. For two months he had worked to the point of exhaustion, without compensation, to help promote the cause of contemporary art, and yet these dedicated opponents of modernism had handed him their highest honor and the equivalent of $6000 for a portrait of his washerwoman's daughter.

Why? The consensus today is that, while many welcomed Bellows as a noble opponent of the status quo, the Academicians saw in his work a decent respect for tradition. Something about the man resonated in both camps, and undoubtedly personal magnetism and force of

Churn and Break
1913
Oil on panel
17³/₄ × 22 in.
(45.1 × 55.9 cm)
Columbus Museum of Art,
Columbus, Ohio: Gift of Mrs.
Edward Powell. 1948.053

On Monhegan Island, the
pounding, crashing surf had
a relentless rhythm that
fascinated Bellows—so much
so that he was willing to set up
his easel perilously close to the
action.

Gregarious as he was, this summer Bellows
seems to have reveled in the sheer solitude
and isolation of this remote speck on the map.
He was seldom reminded of Manhattan
except once a week in August and September,
when the latest issue of *Harper's* arrived on
the mail boat, adorned each time with one
of his drawings.

Bellows had recently seen enough
specimens of humanity (some 75,000 attended
the Armory Show), so he was not looking for
large crowds of people to observe—let alone

to paint. His mentor, Henri, was not around to
make suggestions, and his father was gone, too.
So, in some ways, whether he realized it or
not, Bellows was freer now to make decisions,
artistic and economic, on his own.

In late October 1913, when he returned
to New York, the year, with all its highs and
lows, began to take its toll. Belatedly, the
accumulated effects of stress and overexertion
caught up with him, and, for the first time
since 1907, he did not even enter the winter
exhibition at the National Academy of Design.

Harbor at Monhegan
1913–15
Oil on canvas
26 × 38 in.
(66 × 96.5 cm)
Private collection

One of Bellows's favorite
Monhegan spots was the harbor
waterfront where, every
afternoon, fishermen gathered
to clean the day's catch.
Whenever a boat came in, it
was followed closely by a flock
of hungry gulls.

The Carpenter

Art is a free country and Bellows riots in the liberties of free speech. Here, at least, you bid farewell to the small voice of beauty, become, instead, a raucous and very vehement slang.

Charles L. Buchanan, *George Bellows, Painter of Democracy*, 1914

THE year 1914 began for Bellows with a well-attended and profitable one-man show at the Montross Gallery in New York during January and February. This included a number of his Monhegan pictures, as well as his *Love of Winter*. "A winter scene, by George Bellows," wrote one enraptured critic, "again emphasized the great gifts of this artist. When I think of a Royal Academy Exhibition, and the tremendous concussion bound to ensue in Burlington House if such a dynamic canvas as this skating picture were to be smuggled in among the feeble, colorless mediocrities—! What joy to read the London papers next day!"

In February, the third of Bellows's "Ashcan" drawings appeared in *The Masses*. Here, three hungry tramps are closely inspecting something they have pulled out of a garbage can near the docks. The title was *Real Tragedy*; the caption read "Dey's Woims in It." Gentle Max Eastman,

the editor, thought it was "revolting," but ran it anyway because the art staff insisted.

To nobody's great surprise, Bellows's life-size *William Oxley Thompson* (see p. 82) received the National Academy's Maynard portrait prize at the March–April exhibition, but he probably did not attend the opening. There was to be a mass meeting in Union Square the same night, in support of the estimated 250,000 New Yorkers who had all been out of work during the bitterly cold winter. After the rally, the crowd marched with the spirited Emma Goldman, ninety-three blocks up Fifth Avenue to the Ferrer Center, the site of a progressive school where Bellows sometimes taught. There, the needy would be fed and sheltered for a time, since few charities or churches were willing to help.

Three of Bellows's illustrations appeared in the April 25 issue of *Harper's Weekly*,

Love of Winter
1914
Oil on canvas
32⅛ × 40 in.
(81.6 × 101.7 cm)
The Art Institute of Chicago,
Chicago, Illinois: Friends of
American Art collection
1914.1018
Photography © The Art
Institute of Chicago

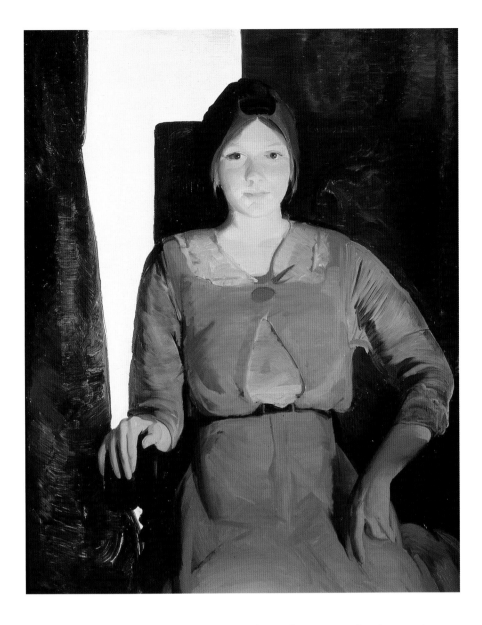

Geraldine Lee, No. 2
1914
Oil on panel
38 × 30 in.
(96.5 × 76.2 cm)
The Butler Institute of American
Art, Youngstown, Ohio: Museum
Purchase, 1941. 941-O-101

Dissatisfied with Bellows's first
attempt at her portrait, which
included her dog and other
distractions, this poised young
lady offered him another
chance. She sat for her second
portrait wearing an outfit whose
unusual colors and textures
undoubtedly posed a challenge
for the artist. Nevertheless, this
is one of his most successful
"society" portraits.

accompanying a short story about young love
and intercollegiate sports rivalry. A week or
two later, his big oil *Cliff Dwellers* (see p. 88)
received third prize and a bronze medal at
Pittsburgh's Carnegie International.

Some time in June, George's little family
returned once again to Monhegan, where they
met with the Henris and Randall and Florence
Davey for a convivial summer of outings,
shared meals, and hard work. Hopes were high
for good, clear weather. Instead, the island was
cloaked in fog almost every day, and there was
little to do but read books, play cards, and paint
each other's portraits. In fact, the great majority
of Bellows's easel works from 1914 are portraits

of friends, family, and well-to-do patrons.
Many were done for his own enjoyment—
certainly this was true of his affectionate
Emma at the Piano (overleaf). Others were
clearly motivated by his perennial need for
money, such as *Willard Straight*, generously
compensated by Straight's relative Gertrude
Vanderbilt Whitney, a dedicated champion of
American art and artists, and a sculptor in her
own right.

Bellows and friends were just settling in
when, late in June, the mail boat brought the
first newspaper reports of the assassination in
Bosnia of Archduke Francis Ferdinand, heir to
the Austrian throne, and his wife. It was just
another of those royal family feuds, many
people thought, but war soon broke out in
Europe. On August 4, 1914, the seriousness of
the situation began to dawn on the residents
of coastal Maine. On that day, a brand-new
German passenger ship, the *Crown Princess
Cecelia*, suddenly emerged out of a dense fog
into the neutral waters of Bar Harbor with all
her running lights off. Before being overtaken
by the fog, the ship had headed out of New York
at top speed, dashing toward the open Atlantic
with a full manifest of European nationals
hastening home after liquidating their American
assets (including $13 million in gold).

As soon as the weather cleared, she was on
her way again, but on Monhegan, only about
sixty miles from Bar Harbor as the seagull flies,
faraway Europe and its problems now seemed
quite real—and a bit too close for comfort.

Back in New York, the *Masses* staff deplored
the violence engulfing most of Europe. In his
September editorial, Max Eastman wrote: "It
is not only the waste of blood but the waste of
heroics that appalls us, and makes all emotion
inadequate. If only we could dip up that
continentful of self-sacrifice and pour it to some
useful end!" Bellows, like many concerned
Americans, probably had similar thoughts in his

Emma at the Piano
1914
Oil on panel
28³/₄ × 37 in.
(73 × 94 cm)
Chrysler Museum of Art,
Norfolk, Virginia: Gift of Walter
P. Chrysler, Jr. 71.617
© George Bellows Estate

Music was an important part of
George and Emma's married
life. She enjoyed accompanying
his rich baritone voice—if not
always his highly eclectic
repertoire. And he liked hearing
her practice on the piano while
he worked, as this memorable
portrait clearly shows.

"Mr. Bellows," a critic
wrote in the *New York Times*,
"paints blue with such
atmospheric quality, such
breadth and depth, that any
other color in one of his blue
canvases is apt to seem an
intrusion."

mind and found no practical way to remedy the situation—at least not now.

At the moment he had an important family matter to deal with. Emma's father, William Story, had recently suffered some serious business setbacks, and it was decided that the Storys should sell their New Jersey house and move in with George and Emma. It was the kind thing to do—and Anne's grandparents could act as live-in babysitters when need be.

This decision made, Bellows plunged into his second-favorite creative activity, which was cabinetmaking. After replacing the worn old floors of his English-style basement, he reconfigured the whole apartment into an attractive suite of rooms with a well-lit living-room and an up-to-date kitchen with dining area, providing closets and cupboards everywhere. Finally, Emma stitched curtains for the windows, and George painted the walls, so that all would be ready for winter, when the Storys would arrive.

Frequently, however, he was called away from his workbench to serve on exhibition juries, and by December he was annoyed enough to fire off a long letter to the *American Art News*, which was published the day after Christmas under the title "An Ideal Exhibition." The following excerpt demonstrates just how cogently George Bellows could communicate, even when he was boiling mad:

During the last two weeks I have served on four juries in three different cities, selecting works for our national exhibitions and the Panama Fair. I have seen things I liked immensely go down and out and things I have disliked immensely accepted with applause. I am not a rare and strange individual; at least I find myself continuously elected to such duties—fighting for what I believe in technically or philosophically, blurting out opinions, making enemies thereby; trying

Drawn by George Bellows.

to push what I feel is important, making quick judgments under the rush of necessity—judgments I would often change had I better acquaintance with some of the hastily seen things—the whole business of helter-skelter, of hit and miss, each man with a definite or indefinite prejudice and limited understanding.

This is all unnecessary, not to say witless; so witless, in fact, that many of our most important and distinguished painters feel either disinclined to send or refuse on principle.

Time is needed to estimate any work of art.

Space is needed to show any work of art.

Congenial company is essential in the hanging of pictures together. Freedom is necessary for the development of all art: freedom to create and freedom to show.

The Masses
January, 1914
Magazine cover
Michigan State University
Libraries, Special Collections,
East Lansing, Michigan:
Oversize HX1.M2

The writers and artists of
The Masses agreed from the
outset to work without
compensation. The costs of
publishing and distribution
were underwritten by a small
group of very wealthy donors,
but there was not enough
money for the magazine to
sustain itself. Few copies were
printed and, because the paper
was of poor quality, few survive.

This Bellows cover design
was based on Vachel Lindsay's
poem *The Congo*.

The Reporter

Rules and regulations are made by sapheads for the use of other sapheads! Laws must be used judiciously. Certain laws, the real ones, are absolute, but many others masking as laws are arbitrary dogmas. The absolute laws, like gravity, or the law of the lever, one is naturally in harmony with and can adhere to in spontaneous work as well as in deliberate effort. The arbitrary laws do not matter. They are man-made, human, fallible points of view. The academies and art schools are full of them.

George Bellows, "The Relation of Art to Every-day Things,"
***Art and Decoration*, July 15, 1921**

Riverfront, No. 1
1915
Oil on canvas
45³⁄₈ × 63¹⁄₈ in.
(115.3 × 160.4 cm)
Columbus Museum of Art,
Columbus, Ohio: Museum
Purchase, Howald Fund.
1951.011

These unsupervised boys
resemble the *Forty-Two Kids*
Bellows had depicted in 1907
(see p. 41), but here the
composition is much more
complex, and much more is
going on. The crowd is greater
in number, and river traffic,
both sail and steam, has forced
most of the swimmers out of
the water. Ominously, there are
three fully dressed adults
approaching from the right, led
by a man in business suit and
homburg striding into the fray,
apparently bent on teaching
some hapless lad a lesson he
will not soon forget.

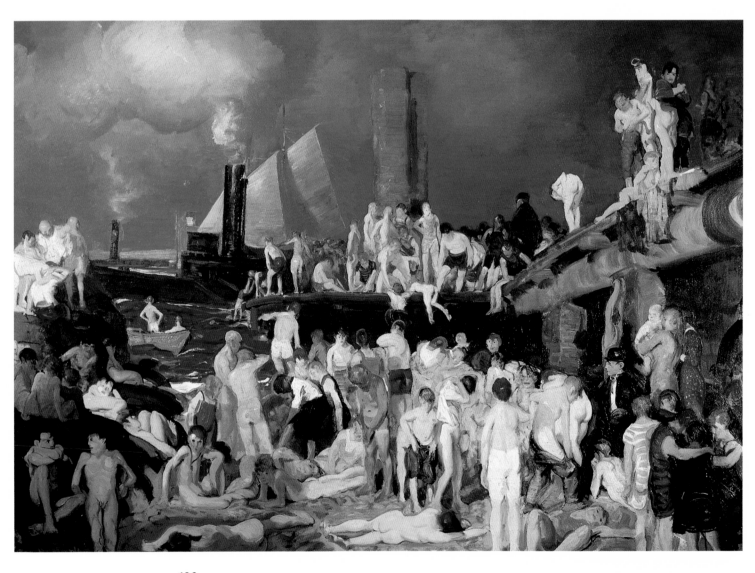

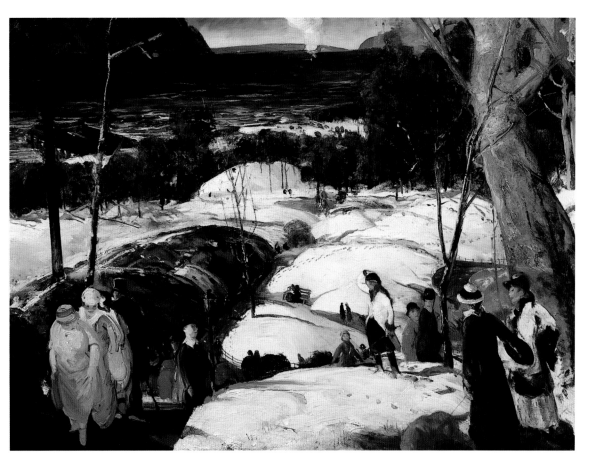

Easter Snow
1915
Oil on canvas
34 × 45 in.
(86.4 × 114.3 cm)
Private collection, Wayne,
New Jersey

Churchgoers and dog-walkers
brighten the riverside landscape
after an unexpected spring
snowfall. In 1925, fellow artist
Ralph Flint wrote of *Easter
Snow*: "This slice of life, like
so many other records Bellows
made, is as real a document of
period and place as any Currier
and Ives plate of earlier days."

N January 1915, Bellows's colorful *Riverfront No. 1* captured the gold medal for "best in show" at the Panama–Pacific Exposition in San Francisco, just as a traveling exhibition, *Paintings by George Bellows*, was making its way toward Los Angeles by way of Chicago and Detroit.

The Storys were now comfortably settled in the East Nineteenth Street house, providing some welcome company for Emma, who was expecting a second child in the spring. As before, they had already chosen the baby's name: Eugene, after George's great friend Eugene Speicher, and, as before, they would have to switch it, this time to Jean.

Bellows's first illustrating assignment of the year came from *Metropolitan Magazine*, whose editors wanted to send him to Philadelphia, along with John Reed, to cover a few days of the Reverend "Billy" Sunday's latest standing-room-only religious revival.

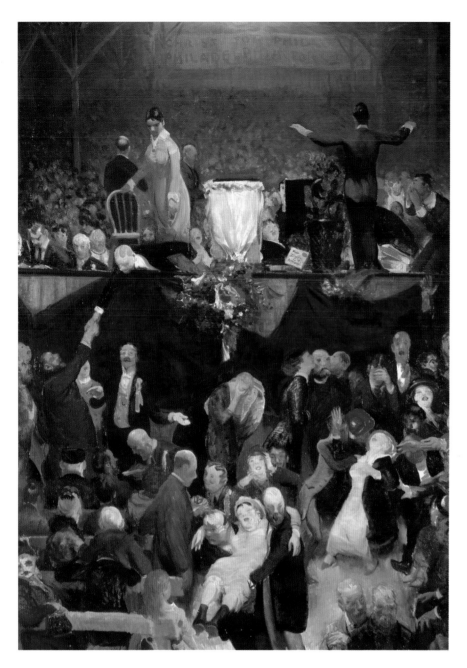

The Sawdust Trail
1916
Oil on canvas
63 × 45⅛ in.
(160 × 114.6 cm)
Milwaukee Art Museum,
Milwaukee, Wisconsin: Layton
Art collection, Purchase.
L1964.7

Bellows already knew "Jack" Reed, who occasionally wrote for *The Masses*, and, as a consummate painter of crowd scenes (a connoisseur of sorts), Bellows had a yen to see Billy Sunday, a former major-league baseball player, in action.

Bellows and Reed made an odd match: George, an Ohio State dropout who seldom met a man he did not like, and Jack, a Harvard graduate in full revolt against the "tyranny" of capitalism and everything it stood for. Reed was after a good story and got it by talking to some of Sunday's backstage supporters; he found them even more bigoted than he had expected. In his article, "Back of Billy Sunday," Reed did not blame the preacher for speaking his mind: "he is just ignorant, that's all."

Both Bellows and Reed were seated in the press box, ideally positioned to see, up close, the shenanigans on stage and to witness the tortured shrieks and moans and swoons of the pastor's enormous flock, as they received blow after blow from the pulpit: threats of eternal damnation to anyone who had ever played cards or ventured on to a dance floor. All of this wrathful oratory, heaped upon the gentle citizens of the "City of Brotherly Love," disgusted Bellows, but, as he told an interviewer from *The Touchstone* two years later:

I like to paint Billy Sunday, not because I like him, but because I want to show the world what I do think of him . . . He is death to the imagination, to spirituality, to art . . . His whole purpose is to force authority against beauty. He is against freedom, he wants a religious autocracy, he is such a reactionary that he makes me an anarchist. You can see why I like to paint him and his devastating "saw-dust-trail." I want people to understand him.

Lucie
1915
Oil on panel
22 × 19 in.
(55.9 × 48.3 cm)
Private collection, Ohio

Lucie Bayard, one of Robert
Henri's art students, was staying
with the Henris in Ogunquit
when Bellows painted this
portrait in 1915. After Bellows's
death a decade later, she helped
his widow with the sad but
necessary job of cleaning and
repairing his remaining
canvases prior to sale.

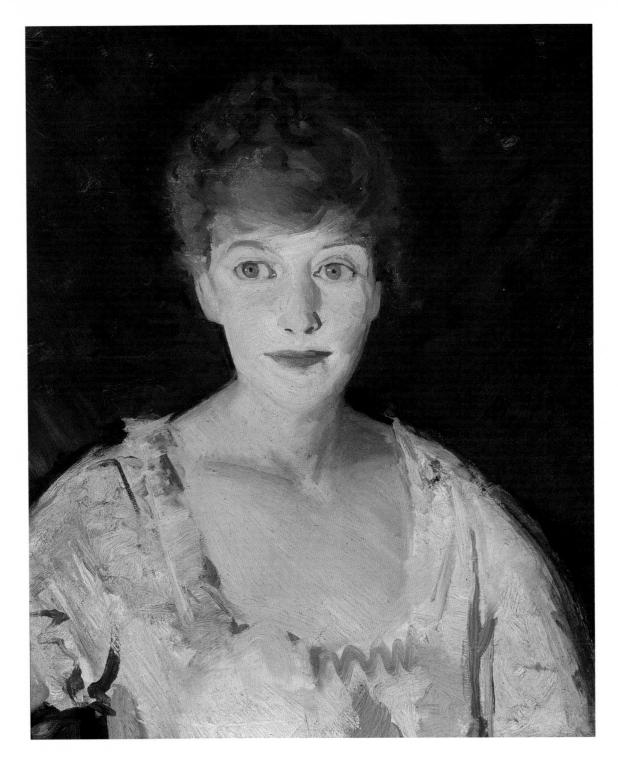

Apparently the Philadelphia experience did little lasting damage to Bellows's sense of humor, because when the Folsom Galleries in New York asked him to contribute something to a show entitled *The American Salon of Humorists*, he sent his "Ashcan" drawing *Real Tragedy*.

Baby Jean arrived on April 23, and it soon became apparent that she took after her father: boisterously energetic and ready for fun. The house on East Nineteenth Street was now occupied to capacity: four adults, five when George's mother came to stay, plus two children and a maid.

In June, the entire extended family climbed aboard the Boston and Maine railroad and headed north-by-northeast to Ogunquit, Maine, a picturesque old town near the dunes that drew droves of artists and would-be artists every summer and where one could purchase a fancy set of watercolors in any drugstore. It was a lot easier to get to than Monhegan, though, and it had no deep harbors to attract U-boats. Everyone knew Woodrow Wilson's neutrality policy was in effect, but the loss of 1198 innocent passengers on the *Lusitania* in April had left America very much on edge. Fortunately the farmhouse they rented was spacious, and despite the rain, the fog, and the inevitable domestic chaos, everyone survived.

Toward the end of the year, Emma, who since their marriage had been supervising and updating George's business ledgers, could announce that her husband's 1915 income was the best it had ever been. George could afford, now, to become a student once again: not in a classroom this time but in his own studio.

The Sketch Hunter

The sketch hunter has delightful days of drifting about among people, in and out of the city, going anywhere, everywhere, stopping as long as he likes—no need to reach any point, moving in any direction following the call of interests. He moves through life as he finds it, not passing negligently the things he loves, but stopping to know them, and note them down in the shorthand of his sketch-book . . . Like any hunter he hits or misses. He is looking for what he loves, he tries to capture it . . . Those who are not hunters do not see these things. The hunter is learning to see and to understand—to enjoy.

Robert Henri, *The Art Spirit*, 1923

Business-Men's Class
1916
Lithograph
12 × 17½ in.
(30.5 × 44.5 cm)
Columbus Museum of Art,
Columbus, Ohio: Gift of Mrs.
Joan Zieg Steinbrenner, Florida.
2002.017.003

In April 1913, Bellows made
his debut in *The Masses* with
a comic illustration much like
this, subtitled *Superior Brains;
Business-Men's Class*, poking
fun at a gymnasium full of
paper-pushers in search of
fitness. This version, drawn
directly on stone, was one of
his earliest lithographs.

GEORGE Bellows's enjoyment of drawing—and of seeing his drawings published—led him to experiment with the printing process itself. Under John Sloan's watchful eye, he first attempted an etching or two but found the medium too dainty and delicate for his long, fast-moving fingers. Then, beginning early in 1916, he tried his hand at lithography, but the method he used was too laborious, and he did not achieve the spontaneity that made his freehand drawings so effective.

Many of his friends advised him not to waste his time, because nobody collected lithographs anymore—people wanted etchings, and, most of all, they wanted etchings with the stamp of Whistler on them. But Bellows was determined to put lithography on the map, and he hired George C. Miller to come to the studio three nights a week and help him do just that.

Miller, highly recommended by other printmakers, was a young pressman who had been employed at the American Lithographic Company since he was fifteen. He was knowledgeable in all the ways his employer was not, especially in the practical science of interacting inks and solvents, grease crayons, and the kinds of paper most compatible with the chemicals involved. Moreover, he never trespassed on Bellows's territory, leaving all aesthetic decisions to the artist. After the stone was inked, he was content to feed the hand-cranked press until the run was complete. Together, the two published almost thirty stones in 1916, several of which were exhibited in the Keppel Gallery in April.

George's recent canvases did well, too: singly or in groups they crisscrossed the Midwest and East, appearing in fourteen major

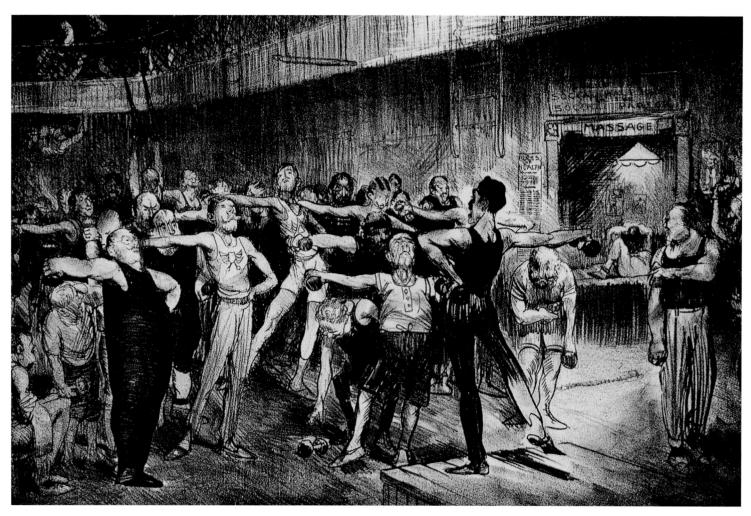

Artists' Evening
1916
Lithograph
8⁷/₈ × 12¹/₈ in.
(22.5 × 30.8 cm)
Columbus Museum of Art,
Columbus, Ohio: Museum
Purchase with funds provided
by a gift from Dr. Hervey
Williams Whitaker, by exchange.
2002.018.005

Genial, white-bearded John
Butler Yeats, the Irish poet's
father, presided over many a
soirée at the Petitpas sisters'
boarding house on West
Twenty-ninth Street. Standing
beside Yeats is Robert Henri,
with George Bellows himself
listening in. Seated at Yeats's
right, Emma Bellows looks over
her shoulder, while Marjorie
Henri sketches at left, down the
table from the resident cat.

107

**Artists Judging Works
of Art**
1916
Lithograph
14⅝ × 19 in.
(37.2 × 48.3 cm)
Columbus Museum of Art,
Columbus, Ohio: Museum
Purchase, Howald Fund.
1959.002

Bellows looked down on the
entrenched art-jury system and
enjoyed taking cartoon-style
sideswipes at it. One of these
appeared in *The Masses* in April
1915, with a disclaimer: "The
result of a young artist's first
service on an official jury. For
fear of offense none of the
'likenesses' will be pointed out.
They are whoever they are." In
this version the "young artist"
can be seen in the back row
at right.

Benediction in Georgia
1916
Lithograph
16⅛ × 20 in.
(41 × 50.8 cm)
Columbus Museum of Art,
Columbus, Ohio: Gift of Friends
of Art. 1936.001

A *New York Times* critic writing
after Bellows's death called his
depiction of convicts dozing,
nodding off, and covering their
ears, "an ineffective blessing at
the end of a prison service. You
can feel in the outstretched
hands of the minister and his
self-confidence and see in the
expressions of the sinister
congregation how without
blessing they all really are."

Westward Ho!

Art is simply a question of doing things, anything, well.
When the artist is alive in any person he becomes an
inventive, searching, daring, self-expressive creature.
He disturbs, upsets, enlightens.

Robert Henri, *The Art Spirit*, 1923

THE year 1917 was one of agonizing inner conflict and overt controversy for the American people, the Congress, the White House, and even the staff of *The Masses*. To intervene in Europe? To conscript troops and arm them? If so, how many and when? If not, how long could the USA continue to "wait and see"? The final decisions, of course, were largely in the hands of the Kaiser himself, and a general mood of uncertainty and suspense pervaded while America held her breath.

At the same time, a new spirit of open-mindedness and mutual cooperation was changing things for the better in the art world. Democracy was in the ascendant—and it had nothing to do with flag-waving patriotism.

On January 9, for example, George Bellows and twenty-seven other artists, Impressionist painter Childe Hassam among them, met to organize the Painter–Gravers of America. The idea was not only to hold exhibitions but also to educate the public at first hand through regularly scheduled demonstrations of the steps involved in the printmaking process.

The first of these events occurred late in January at the Anderson Gallery, where George Bellows, Albert Sterner, Joseph Pennell, and Bolton Brown, all well-known printmakers, exhibited their individual techniques before a large audience of potential collectors: so large, in fact, that at least a hundred had to be turned away at the door.

That same day, Woodrow Wilson went before the Senate to plead for a peaceful conciliation in Europe. Promptly, Germany responded, announcing that submarine warfare would immediately resume: "All traffic will be stopped with every available weapon and without further notice." By February 3, all diplomatic relations with Germany were

I Remember Being Initiated Into the Frat
Before 1917
Graphite, conté crayon, and ink on paper
19 × 23½ in.
(48.3 × 59.7 cm)
Columbus Museum of Art, Columbus, Ohio: Gift of Mrs. Joseph R. Taylor. 1940.020

Beta Theta Pi, the oldest fraternity west of the Alleghenies, was founded in 1839 to "build men of principle" holding "high standards of moral conduct and responsible citizenship." OSU's Beta chapter initially overlooked Bellows, but his considerable accomplishments—especially in athletics—led to a reconsideration and pledge in 1902. Later, Bellows recalled his initiation in a critical lithograph that is an unflattering examination of fraternity hazing.

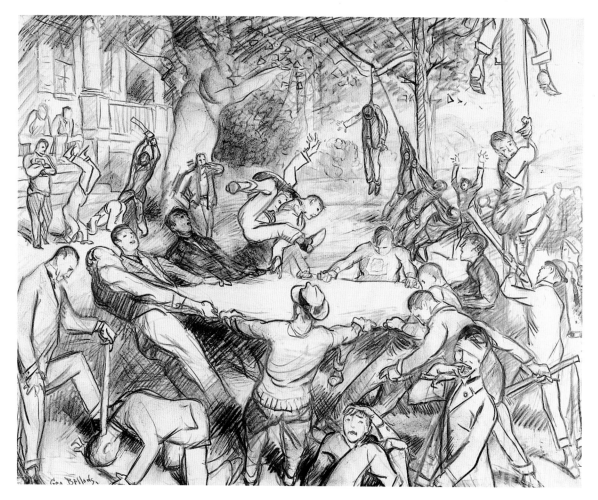

severed, and Wilson asked Congress for war powers, in case they might be needed to counter an overt act.

On March 9, the US began to install armor and weapons on its merchant ships. Still, art exhibitions continued, crisis or not, including one that opened on March 13 at the Milch Gallery, New York: *Paintings*, *Lithographs*, *Drawings, and Etchings by George Bellows*, and, in the last week of March, came the *First Annual Exhibition of the Society of Painter–Gravers*, held across from the Plaza Hotel on Fifty-eighth Street.

Fatefully, on April 6, Wilson announced that "a state of war exists between the United States and the Imperial German Government." On that day, eighteen German ships lay at anchor in New York waters, some well up the Hudson River. All were seized by US Customs agents, the American flag was hoisted over the

SS *Vaterland* (the first official act of war), and all ships' officers and personnel were delivered to Ellis Island. While this was going on, Bellows and others were busy across town setting up the *First Annual Exhibition of the Society of Independent Artists* in Grand Central Palace.

This remarkable show, which opened on April 10, 1917, displayed an unprecedented 2400 works. The newly formed society had 1130 members, who were promised "no jury, no prizes," though a nominal fee per entry was required, and the art was displayed alphabetically according to the first initial in the artist's surname. John Sloan, who was drafted to manage this exuberant enterprise, wrote: "And what a show it was! Good work, bad work, works of genius, trash; every school of art from real, or imitation, Primitive to the *dernier cri* of French abstractionism."

Initiation in the Frat
1917
Lithograph
13 × 21¼ in.
(33 × 54 cm)
Columbus Museum of Art, Columbus, Ohio: Given in honor of James F. Weidman's long, distinguished service to the Columbus Museum of Art by his friends and the Artizens. 1995.008

In 1917, Bellows's lithographs began to address more serious matters. *Initiation in the Frat*, for example, is far less jocular than the drawing he made of the same event some years earlier.

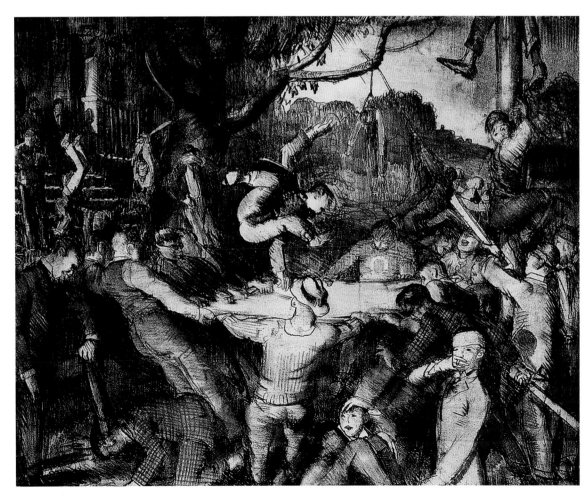

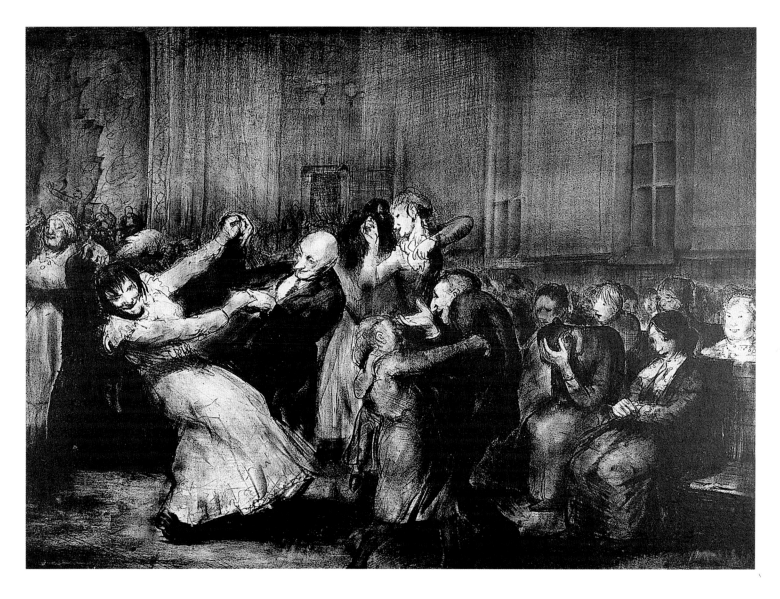

Dance in a Madhouse
1917
Lithograph
18¹/₄ × 24¹/₄ in.
(46.4 × 61.6 cm)
Columbus Museum of Art,
Columbus, Ohio: Gift of Mrs.
George S. Munson. 1966.004

Based on drawings made in
Columbus a decade earlier
and published in national
magazines, this large lithograph
is essentially a collection of
individual portraits. "Here is,"
wrote Bellows, "the happier
side of a vast world which a
more considerate and wise
society would reduce to a not
inconsiderable degree."

Writing in the *New York Sun*, noted art critic
Henry McBride said:

*First of all I should like to say that I regard the
show as an artistic success: a success far
beyond what I had thought possible for the first
year of such an organization. It interested me
beyond any other public exhibition of the
season. In fact it has been the only exhibition
of the year that has much interested me, that
has made me think and that has forced me to
recall that there are artists living in America
who are confronted with American problems.*

Although a good time was had by all, the
enterprise lost money. Sloan attributed the

loss partly, at least, to the crescendoing
rumbles of war.

June 14, 1917 was National Draft Registration
Day for all men between the ages of twenty-one
and thirty-one. For the time being, Bellows,
now thirty-four, was not affected. Only a year
later, when the third and last call was issued,
for men eighteen to forty-five, was he in any
danger of being drafted, but even earlier the
possibility had weighed on his mind.

By the middle of June, the first US troops
were on their way to France, but Bellows was
about to head in the opposite direction. "I am
going out to California," he said in a *Touchstone*
interview, "and paint my head off—and then I'll
do my stunt for democracy—if it comes out that

way. I cannot put my finger on my war psychology at all . . . I hate the thought of fighting—but I am all for democracy. You see it tangles a fellow up pretty badly. I guess most men would feel mighty sick at the thought of a bayonet. To me the bayonet is the worst part of war. And yet the bayonet is the great call to democracy."

The trip to California had been arranged by Bellows's longtime patron Joseph Thomas. Some friends of Bellows—Stephen C. Clark, a Yale graduate and mineowner, and his wife—wanted him to paint the portrait of their young son Paul, and Mr. Clark offered a price he could not refuse: enough to pay for a big summer treat for the whole family in the Far West. Bellows wished the faithful George Miller a pleasant summer, said goodbye to his family, and took the westbound train alone, to pick out a nice place for them to stay within reach of San Mateo, where his client awaited.

Carmel, on the Monterey Peninsula, had great appeal, being well supplied with writers, musicians, and other interesting types. Bellows rented a house in a part of town called "The Bohemian Grove," an early version of the counterculture enclaves for which California later became famous. In a letter to Henri he wrote: "This is an artists' colony, wonderfully ugly. Looks like a Methodist camp meeting ground (in spots). We have the 'Queen's Castle,' the most pretentious dwelling here with lots of rooms and a fine garden of flowers and trees looking out on the sea and almost on the beach."

Perhaps because Emma was not there to talk him out of it, he also bought a big, beautiful Buick touring car and taught himself to drive, so that when Emma and the girls got off the train, they were introduced to "Georgette," the new Buick, and driven to their temporary home in high style.

Bellows completed Paul Francis Clark's portrait to everyone's satisfaction, and in the 1920s his father acquired additional Bellows works. Between sittings Georgette took the entourage to see and sketch Pebble Beach, Big Sur, the Carmel highlands, the seal rookeries, the old Spanish missions, and, of course, the pelicans and the inscrutable Pacific.

Toward the end of September, George drove Emma and the children all the way from Carmel to Santa Fe, New Mexico, to visit the Robert Henris and the Leon Krolls. Henri, who had discovered the charms of Santa Fe only a year earlier, was now elegantly ensconced in a big adobe house on Palace Avenue, not far from the ancient Spanish Governor's Palace. He, too, had bought a new car, a Model T Ford called "Henrietta," and the whole houseful drove in convoy to several traditional Pueblo ceremonies near Taos, explored the foothills of the Sangre de Cristo Mountains, and took a distant look at the Rockies.

Bellows was needed back in New York by November to teach some classes at the Art Students League, and to save time he put Georgette on a flatcar and took his family home by train, wishing they could have stayed a little longer.

At least four months had flown by since Bellows and Miller had last used the lithograph press, but they made up for lost time by the end of the year with such memorable images as *Stag at Sharkey's, Dance in a Madhouse, Benediction in Georgia* (see p. 108), *Electrocution* (overleaf), and a black-and-white version of *Cliff Dwellers* entitled *The Street*.

Although most of his daytime hours were spent at the Art Students League, whenever he was free Bellows haunted the new *Thomas Eakins Memorial Exhibition* at the Metropolitan Museum of Art. Along with Winslow Homer, Manet, and Velázquez, Eakins had always been one of his favorite painters. In his estimation, Eakins was "one of the best of all the world's masters. [This is] the greatest

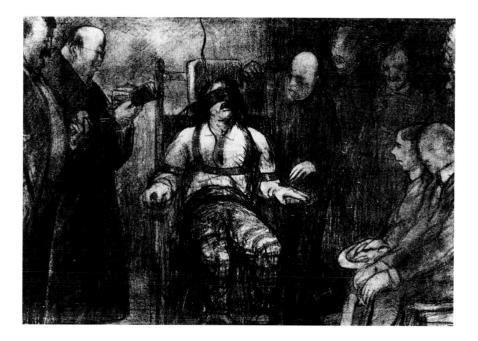

Electrocution
1917
Lithograph
8³/₁₆ × 11³/₄ in.
(20.8 × 29.9 cm)
Columbus Museum of Art,
Columbus, Ohio: Museum
Purchase with funds donated
by George and Nannette V.
Maciejunes, in memory of James
M. Vicars. 2001.004.001

In 1890, New York became the
first state to employ the electric
chair in capital-punishment
cases. Newspapers routinely
sent reporters to witness
executions. Bellows's friend
Jack Reed had been to Sing Sing
Prison recently in this capacity,
and his gruesome account may
have inspired the lithograph.

Electrocution, Small Detail
1917
Lithograph
8¹/₈ × 6 in.
(20.6 × 15.2 cm)
Columbus Museum of Art,
Columbus, Ohio: Museum
Purchase with funds donated
by George and Nannette V.
Maciejunes, in memory of James
M. Vicars. 2001.004.002

In subsequent versions of the
electrocution lithograph,
Bellows eliminated witnesses,
one by one, until only the victim
and his executioner remain.

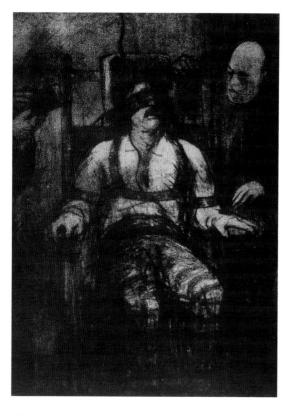

one-man show I've ever seen and some
of the very greatest pictures."

During Bellows's absence, *The Masses* had
been buffeted by numerous investigations and
indictments based on its strong anti-war
editorials and cartoons. Although Bellows had
contributed one of the latter, *Christ in Chains*,
to the July issue, it was Max Eastman and art
editor Art Young who bore most of the burden.
They were indicted not once but twice under
the Espionage Act, and the Post Office
Department refused to deliver certain issues,
citing the same grounds. The trials, which
exonerated Eastman and Young, dragged on
for many months. To all intents, the magazine
was out of business by December.

Ten years later, summing up his years
as art editor, Young mused:

Inadequate as it was, The Masses *helped to
open the way for that which is individual in
art and literature. This alone was annoying
enough to a public brought up on the pap of
prettiness and the trite. But our real offense,
our "crime," was voicing opinions that were
irritating to financial rulers. Not one of us,
I think, but knew that their iron juggernaut
had the right of way and that we were just
throwing things at it.*

*Whether it was worth while is to ask
whether life itself is worth while.*

Some of the original staff regrouped to start
another radical magazine, but, by January 1918,
George Bellows had finally made up his mind to
join the war effort—in his own way and on his
own terms.

The Warrior

The Government has at last, we think, got on the right track in the matter of its posters and propaganda drawings. It is relying more and more on the painters and less on the designers of so-called "popular" posters . . . The fact that painters of such high rank as Gari Melchers, George Luks, Paul Dougherty, Childe Hassam, and George Bellows are at last turning their attention to such sorely needed work as this, and—what is even more miraculous—getting the co-operation of the Government, is something that ought to make every lover of good art abundantly grateful. Too long have we suffered under the undivided thralldom of "popular" posters. Let everyone praise Heaven that our really great painters are at last helping out at the wheel.

"The Hun," ***Vanity Fair***, **November 1918**

Edith Cavell
1918
Oil on canvas
45 × 63 in.
(114.3 × 160 cm)
Museum of Fine Arts, Springfield,
Massachusetts: James Philip Gray
collection. 49.02

Edith Cavell, a British Red Cross
nurse and matron of a hospital in
German-occupied Belgium, was
a heroine of World War I. After
she helped some Allied prisoners
reach safety across the Dutch
border, she pleaded guilty at her
trial and was executed by firing
squad on the night of October 11,
1915. Here she descends the
prison stairs on her way to
execution. Her last words were
"patriotism is not enough." Royal
Cortissoz of the *New York
Tribune* called Bellows's canvas,
showing Cavell on her way to
execution, "a masterly work
striking in its tragic appeal and
somber beauty; one of the
noblest pictorial achievements
of our time."

AFTER a long-scheduled January–February
Exhibition of Paintings by George Bellows
held in Columbus, Bellows, armed not with a
bayonet but with a blunt black grease crayon,
marched as an army of one into a faraway
war zone that existed only in his imagination.
This battleground first became real to him in
May 1915, when he read *His Majesty's
Government's Report of the Committee on
Alleged German Outrages*, known as "The
Bryce Report," excerpted at length in the *New
York Times*. Not to be outdone, the *New York
Tribune* carried Richard Harding Davis's
chilling account of the German march through
Brussels, which added further ugliness to the
growing literature of the Kaiser's atrocities:
massacres, kidnappings, dismemberings, rapes,

and brutal treatment of civilian men, women, and children. More recently, in February 1918, *Everybody's Magazine* had begun publishing installments of the deeply disturbing *Belgium: The Crowning Crime*, written by Brand Whitlock, a former mayor of Toledo and, at the time, US ambassador to Belgium.

Perhaps if Americans could see with their own eyes the kinds of human suffering inflicted every day in Europe, they might cast off some of their indifference and help to put a stop to the carnage. Apparently Bellows thought so, for he worked tirelessly from the spring of 1918 until after the Armistice to give visibility to what had been mere hearsay until now.

Known for his unwavering optimism and love of life, George Bellows is hard to envision in the role of a modern-day Daumier or Goya, but skeptics of his generation were in for a surprise when the art critics weighed in:

The works are brutal, full of horror, but reeking with truth, which adds to their poignancy. After one has recovered (if one does!) one sees that the pictures are full of a strange beauty, conceived in bigness of vision that is rare and inspiring.
(*American Art News*, September 14, 1918)

No other artist has placed the Hun before us with such utter and revolting truthfulness as Bellows has done. It required just his temperament to portray the incredible being in action—grinning with fiendish joy as he nails a helpless prisoner to a barn-door with knives, or smoking a cigarette in the presence of a woman whose left hand is upraised and pinned to the wall by a bayonet, or leering at the horror-stricken peasantry who are the victims of his insane rage for blood. … We rank Bellows as the contemporary genius whose real powers were brought into action by the war, and whose war lithographs will be in years to come classed among the most thrilling pictorial records of its unspeakable horrors and crimes.
(*Boston Evening Transcript*, January 13, 1919)

Even George's boyhood idol Charles Dana Gibson, acting as chairman of the Division of Pictorial Publicity in Woodrow Wilson's Committee on Public Information (read: propaganda) wrote him a note of thanks: "Certainly they are the finest things that have been done anywhere, anytime."

After completing his series of eighteen war lithographs, Bellows drove the family in midsummer to Middletown, Rhode Island, where they could enjoy the simple comforts of a farmhouse overlooking Narragansett Bay. It was close enough to Newport for them to attend world-class tennis tournaments at the Casino Country Club, but secluded enough to insulate them from Newport's lavish social life. George still had some war pictures to do, a set of paintings on canvas based on the lithographs but in a much larger and more theatrical format, including *Massacre at Dinant*, now in the Greenville County (South Carolina) Museum of Art, which measures 49½ by 83 inches.

The Bellowses remained in Middletown well into autumn. George and his friend Eugene

George Bellows in his Buick, "Georgette" Circa 1918
Amherst College Archives and Special Collections, Amherst, Massachusetts: George Wesley Bellows Papers, Box 5, folder 2

"Georgette," the Bellowses' Buick, is loaded for an excursion with Elinor, "Aunt Fanny," in front, and Anne and Grandmother Bellows in back. The photograph was probably taken in Rhode Island during the summer of 1918.

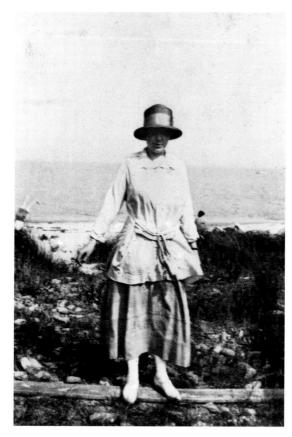

Speicher had volunteered earlier for the Army Tank Corps, giving Middletown as their temporary address, but it was becoming clear that the war was nearing its conclusion, and soon there would be no further need for America's tanks in France.

In October, George found time and energy to look around himself purely for pleasure: *Fishermen's Huts, Bull and Cows,* and *Second Beach, Newport* marked the end of a very busy summer, but for him the war did not come to a halt on November 11, 1918, Armistice Day. His atrocity series, intact or in parts, was in demand all over the country for many more months, creating, undoubtedly, an unprecedented amount of correspondence. But the more clerical work he could accomplish, the greater his sales and the greater the public awareness of lithography as an art worthy of respect.

And there was still another war-related commission to fulfill. Quite unexpectedly, he was approached by an emissary of Duveen Brothers, on behalf of Helen Clay Frick, the thirty-year-old daughter of the collector Henry Clay Frick. In honor of the American Red Cross, she wanted a pair of mural-size canvases, 104 by 79 inches, to commemorate the cessation of hostilities. Here, finally, Bellows gave the heroic Allies a chance to come forward and take a well-deserved bow. In *Dawn of Peace*, a bandaged soldier is being helped outdoors by a Red Cross nurse as doves of peace float from the sky. In *Hail to Peace*, a different nurse, surrounded by young children and their mother, points to a dove in the sky, and the children wave. Bellows liked the second design so much that it became the model for his family's 1918 Christmas card.

The Second City

It's a queer thing about models. Do you know some people have the design of a painting in their features and their bodies, and some haven't. I have seen beautiful women whom you couldn't paint at all, you couldn't get a design from them, you couldn't make their bodies compose. And along comes a little girl, not especially pretty, not striking, but you can paint her; she can make designs for a dozen paintings.

George Bellows, "The Big Idea," *Touchstone*, July 1917

BY the end of 1918, the disasters of war had weighed on Bellows's mind and darkened his mood for too long—even he could see that—and it was time to change the subject. As the year waned, Marie Sterner, his good friend and business agent, brought some excellent news: the prestigious Knoedler Gallery wanted to honor him with a big solo exhibition, to open in April 1919.

Some new pictures would be needed to add fresh interest to the display, which was to feature the very best earlier canvases he was willing to part with. Bellows, determined to make the most of this opportunity, sprang into action. It was nearly Christmas, and his first thought was to make a large version, in cheerful colors, of his 1916 lithograph *The Studio*, with the children playing with Santa's new toys while their mother poses for her portrait in a lacy white gown. Grandmother Story talks on the telephone, George Miller mans the lithograph press on the balcony, and the father concentrates on the canvas before him. Then he painted *Old Lady with a Blue Book* ("Old Lady" usually meant Bellows's Aunt Fanny), *Anne in Blue-Green Silk*, and several others that might make a fine showing on Knoedler's red velvet walls.

The exhibition was indeed a success—a huge one—both critically and financially. It brought in nearly $10,000, and, even after commissions were taken, the sum was more than he had ever made in an entire year, equivalent in spending power to more than $100,000 today.

The next big family event was already scheduled: another summer at Miss Appleton's Rockridge Farm in Middletown for George, Emma, the girls, and Grandma Bellows. They loaned their New York house to Joseph Taylor and his wife, leaving them detailed instructions as to where to go and whom to meet. The war was over now, so George, with a clear conscience, could paint whenever and wherever he wanted. Narragansett Bay was serene and tranquil compared with the undomesticated furies of the Maine coast. All told, he painted nearly a dozen outdoor studies, giving them such romantic titles as *Clouds and Meadows*, *Swamp Pasture*, and *Paradise Point*. And for variety there were *Tennis at Newport* (see p. 130) and *Children on the Porch* (see pp. 126–27), as well as several portraits. Every day was full of pleasure and achievement. There was just one fly in the ointment. Her name was Maud Murray Dale, an ambitious amateur artist and writer, the wife of Chester Dale, a self-made millionaire.

Back in April, she had summoned Bellows to her New York residence to discuss having her portrait painted. He knew from long experience that he was not always successful with strangers in the model's chair, but apparently Mrs. Chester Dale was not someone to say "no" to. Throughout the spring of 1919, he labored over the job, but there were always changes to be made: different poses, different outfits, different chairs, with and without her pet dog. By the end of the summer, Bellows had done at least three, some say four, portraits, because she tracked him down in Rhode Island. Two of them have survived: one in the National Gallery of Art, Washington, D.C., another at the Metropolitan Museum of Art. In 1922, Bellows consented to a similar request from her husband (*Portrait of Chester Dale*), who was described decades later in a *New Yorker* profile as "the only man who has had his portrait painted *seriatim* by Robert Reid, George Bellows, Jean Lurçat, Diego Rivera, Miguel Covarrubias, and Salvador Dalí."

All too soon, the breeze off Narragansett Bay turned chilly, and the Bellows family went home in time for Anne's second year of school. George had a few group shows to prepare for, but he and Emma were already looking forward

Emma in the Black Print
1919
Oil on canvas
40¹⁄₈ × 32¹⁄₄ in.
(101.9 × 81.9 cm)
Museum of Fine Arts, Boston,
Massachusetts: Bequest of
John T. Spaulding. 48.518
Photograph © 2007 Museum
of Fine Arts, Boston

Emma Bellows, posing in one
of her old-fashioned costumes,
seems preoccupied, or tired, in
this formal portrait, painted
during the summer of 1919 in
Middletown, Rhode Island.

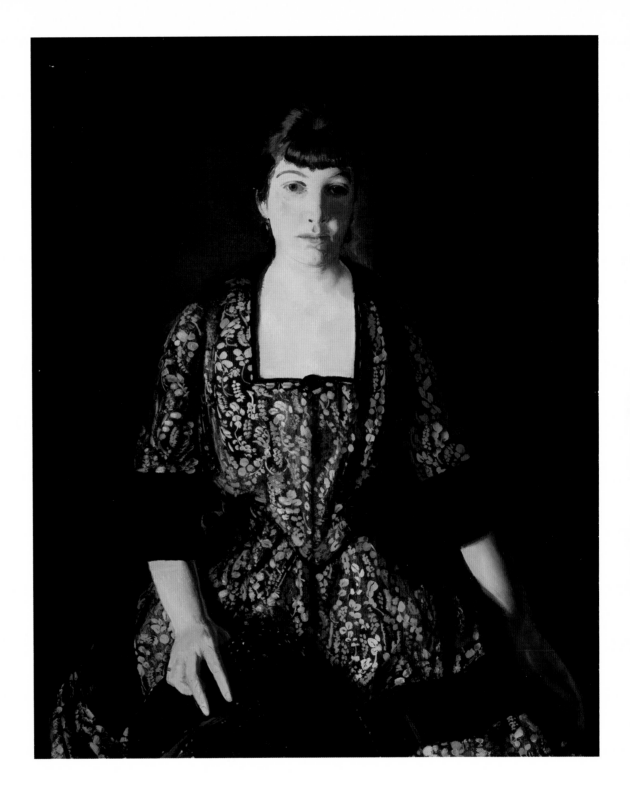

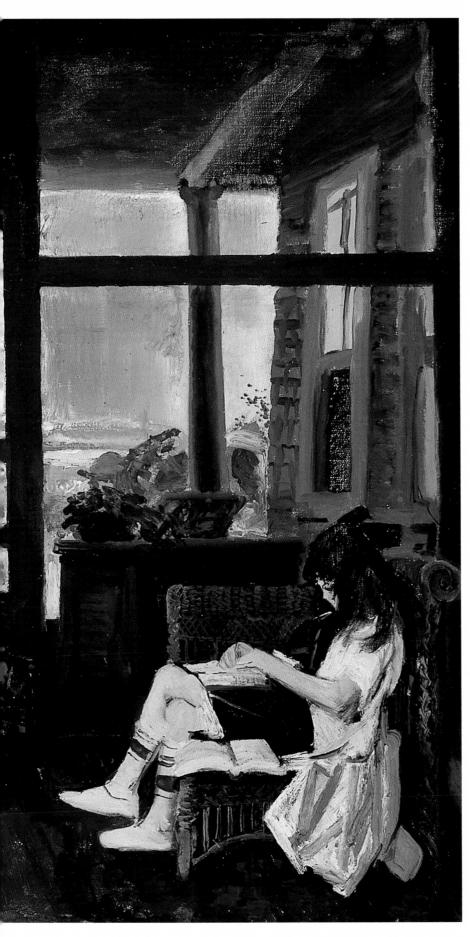

Children on the Porch
(or On the Porch)
1919
Oil on canvas
30¹/₄ × 44 in.
(76.8 × 111.8 cm)
Columbus Museum of Art,
Columbus, Ohio: Museum
Purchase, Howald Fund.
1947.094

Whiling away a drizzly summer
day in Middletown, Anne, Jean,
and their cousin Margaret Story
find quiet things to occupy them
on the screen porch while their
portraits are being painted.
Bellows paid a dollar per
sitting, which made the children
feel like professional models.

to the next big event, a six-week sojourn in Chicago. A major exhibition, *Paintings by George W. Bellows*, was to open at the Art Institute of Chicago on November 1, and, during the subsequent weeks, he was to give a course of lectures and demonstrations to the students.

Anne and Jean stayed at home with the Storys for what must have seemed an eternity to them. Their parents, who were probably expecting a quiet, grown-ups-only interlude, could not have been more surprised: from the moment they arrived they were entertained everywhere with dinners, receptions, concerts, plays, tea parties, luncheons, and tours of the city. George had been sending pictures to the Art Institute's annual exhibitions ever since 1907, but he had never actually visited Chicago—and nor had Emma—and they found America's Second City fascinating.

The Art Institute of Chicago, founded in 1866, was housed near Lake Michigan, in an elegant building dating from 1893, the year of the great World's Columbian Exposition. The hospitable young director, George W. Eggers, showed Bellows through all the galleries, and then he was on his own. During the first session, he spoke to his students as Henri had spoken, urging them to be bold, not to be afraid of your own shadow, decide what it is you want to say and say it loud enough for others to hear, and so on. Bellows knew the words by heart.

On the second day, however, the topic seems to have been portraiture, particularly the importance of getting one's first impressions down on canvas before, not after, one loses one's nerve: "Do it in one day," Henri always said. "Do it in an hour if you can!" Bellows then ushered in the day's model and announced that it was even possible to make a decent, recognizable, head-and-shoulders portrait

sketch of her in ten minutes. Murmurs of disbelief must have been audible all around the studio. "I'll prove it to you," he probably said, in the manner of William Merritt Chase. And, borrowing a new canvas from one of the students, he swung into action, while someone kept track of the passing minutes. With his big, bold brush he produced a charming—if hasty—portrait, complete with a smoothly painted but plain background. The unnamed model looks uneasy, as though she was unfamiliar with such surroundings—but that was part of the first-impression idea Bellows wanted to instill: do not wait until you think you have mastered technique; by that time you will have forgotten why you went to art school—to express yourself. In the late 1990s, this sketch, *Young Black Woman*, surfaced in an art gallery in Santa Fe. Mel Williams, the student who had loaned Bellows his canvas, had preserved this memento all his life. On the reverse is written: "10 minute sketch by George Bellows, Art Institute of Chicago, November 4, 1919 / Mel Williams."

Later in November, Bellows fired off a note to his long-ago English professor:

Dear Joe and Esther Taylor
Work here is delightful and we are having a great reception. We will top it off with a week in Taylorville. I haven't any news or other motive for writing this letter except that I was just naturally thinking about you. They seem to think I know a lot about painting out here and I haven't, consciously, done anything to dispel the illusion. That is, some do and some don't, and they have quite a lovely time about it. I'm trying to stay neutral.
Yours,
Geo.

Woodstock

Whoever has made a voyage up the Hudson, must remember the Kaatskill mountains. They are a dismembered branch of the great Appalachian family, and are seen away to the west of the river, swelling up to a noble height, and lording it over the surrounding country. Every change of weather, indeed every hour of the day, produces some change in the magical hues and shapes of these mountains, and they are regarded by all the good wives, far and near, as perfect barometers. When the weather is fair and settled, they are clothed in blue and purple, and print their bold outlines on the clear evening sky; but sometimes, when the rest of the landscape is cloudless, they will gather a hood of gray vapours about their summits, which, in the last rays of the setting sun, will glow and light up like a crown of glory.

Washington Irving, *Rip Van Winkle*, 1820

THE upper Hudson Valley above Kingston, New York, belonged to the ghosts of Thomas Cole, Frederic E. Church, and Washington Irving until the early 1900s, when a new generation of romantics discovered its matchless skies and ever-changing topography. First came a band of artisans and designers devoted to preserving, in the manner of William Morris, the age-old manual skills fast disappearing in an age of factory-made furniture, ceramics, and textiles. Later arrivals included writers, composers, landscape painters, and others in search of peace and quiet as an antidote to the clash and clamor of city life. By 1920, Woodstock, which during the nineteenth century was an industrial village of glassblowers and quarriers, had become a pleasant place of retreat, unpretentious but very much alive.

At the urging of their friends the Speichers, George and Emma drove up late in April 1920

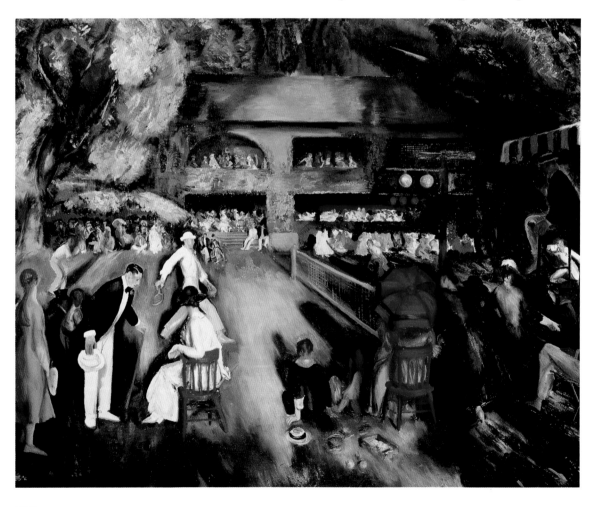

Tennis at Newport
1920
Oil on canvas
43 × 54 in.
(109.2 × 137.2 cm)
Private collection

This is the last of three Bellows paintings of this subject, the first two from on-the-spot sketches, and this time from memory. Approaching the net, in all likelihood, is US champion William Tatem "Big Bill" Tilden, Bellows's all-time favorite tennis player.

Aunt Fanny and Grandma Bellows with George, Anne, and Jean Circa 1922
Amherst College Archives and Special Collections, Amherst, Massachusetts: George Wesley Bellows Papers, Box 5, folder 2

Aunt Fanny, Jean, Anne, and Grandma Bellows share a big giggle as George pretends to be suffering a severe nervous breakdown in Woodstock, New York.

to reconnoiter the possibility of spending some time there themselves. The Art Students League of New York held a summer school for landscape painters in Woodstock, and George was interested in seeing the facilities, so this was partly a business trip—and they had some other friends in the area: Stephen C. Clark, his California patron, had a place in Cooperstown, and Bolton Brown, the lithographer, lived near by in Zena.

Bellows had lost his printing assistant when, in 1918, George Miller joined the Navy, and he had been looking for a good replacement ever since. Perhaps a conversation with Brown would bear fruit. Two years without any lithographs to speak of had left an emptiness in his life, for his imagination was still overflowing with black-and-white images never printed. Bolton Brown, not only one of the most respected lithographers of his generation, but also an enthusiastic outdoorsman and wintertime resident of New York City, was an ideal candidate, and, by early 1921, the two men were turning out the most nuanced lithographs of Bellows's career.

Before heading home, George signed a six-month lease on the so-called Shotwell House, owned by a distinguished Columbia University professor of history and international law, Dr. James T. Shotwell. It was costly, but nowadays he could afford it, and he and Emma would return in June for certain.

Back in the city, Bellows helped with the *Fourth Annual Exhibition of the Society of Painter–Gravers* at the Anderson Gallery and arranged for the transportation during his absence of dozens of his pictures destined for upcoming group exhibitions around the country in Chicago, Buffalo, Cincinnati, Detroit, Los Angeles, Pittsburgh, and Providence. Marie Sterner probably took care of the works to be sent to London, Paris, and Venice. During all these chores, he still found time to paint the lovely *Spring, Gramercy Park* and another version of *Tennis at Newport*.

The whole Bellows family arrived at the Shotwell House in June: George, Emma, Ma, Jean, Anne, and the newly widowed Aunt Fanny. There was plenty of room for all of them, and, for the first summer vacation in his married life, there was a studio for George—with a door on it.

He painted that summer as if he had been let out of a cage: landscapes, portraits, and nudes, as well as pigs, chickens, donkeys, and cats. In August, he wrote to Henri: "I am afraid I am getting into the Woodstock habit of working a month or so on a 'Masterpiece.' We will see what we shall see." The three masterpieces of this first summer in Woodstock were undoubtedly *Elinor, Jean, and Anna* (see p. 135), *Aunt Fanny (Old Lady in Black)* (see p. 134), and *Anne in White* (see p. 133).

By the end of November, they were back in New York, where Bellows and Brown made final arrangements for getting the dusty lithograph press moving again. Bolton Brown proved to be an excellent diagnostician. Up to now, he told Bellows, he had been using the wrong stones—they were far too porous. He had been using the wrong crayons, too, and

from now on Brown would be making them himself. Moreover, Bellows should stop using such absorbent paper. Both of them were self-confident to a fault and considered themselves irrefutable experts in many fields, but in this case Bellows yielded to his colleague's suggestions, and a noticeable improvement brought applause in the press when, in early May 1921, Frederick Keppel and Company opened its *Exhibition of Original Lithographs by George Bellows*. "The printing is done by Bolton Brown," wrote the *Times* critic, "and the delicacy of the relation between the various gradations is scrupulously kept. It is handsome lithography and entertaining art."

Throughout the winter and spring of 1921, some sixty lithographs, in runs of fifty each, streamed from the press. By the end of the season, Bellows had to build a much larger cabinet in which to keep them until needed. In subject matter they ranged from social satire (*The Indoor Athlete, The Parlor Critic*) to intimate portraits of friends and family, scenes from his youth (*Sunday 1897*; see p. 136), caricatures of fellow artists, which presumably were not for exhibition, a number of prizefights, and versions of such previously successful

paintings as *The Sawdust Trail* (see p. 102).

After the Keppel show, Bellows and his entourage returned to the Shotwell House in Woodstock, where George, along with Robert Henri and Leon Kroll, would be teaching at the Art Students League summer school. His halcyon summer was interrupted in mid-July by a summons from the *New York World* to attend a prizefight in Jersey City between light-heavyweight world champion Georges Carpentier of France and US challenger Jack Dempsey. Held outdoors on a hot day, the bout drew ninety thousand boisterous fans, most of them hoping to see Dempsey, an alleged draft dodger, beaten to a pulp.

Bellows drew many sketches of the action, but it was all over in the fourth round, when Dempsey knocked out the champion, to a thundering chorus of invective from the stands. Of all the sketches, Bellows chose for the *World* a scene that took place before the starting bell, when Carpentier still looked like a good bet. Back in Woodstock, with Bolton Brown's press, he ran off two lithographs: *Introducing Georges Carpentier* and *Introducing the Champion No. 2*. Later in the year came *Counted Out, A Knockout* (see p. 136), and *The Last Count*.

The summer-school teaching job gave Bellows great pleasure. He was out of doors with his pupils most of the time, painting hills and hollows, clouds and ponds, orchards and pastures—perhaps, too, a sunset now and then, because they sometimes lost track of the time. His studio, furnished with borrowed furniture and a homemade model stand, was the setting for some outstanding portraits that summer: *Jean in a Pink Dress* (see p. 137), *Katherine Rosen, Portrait of My Mother, No. 1* (see p. 138), and *Anne in the Purple Wrap*.

In Woodstock, most non-essential work was suspended for a week or so every August, to prepare for the huge annual Maverick Festival, a sort of highbrow country fair featuring

Hudson at Saugerties
1920
Oil on canvas
16 × 23⁹/₁₆ in.
(40.7 × 59.8 cm)
Columbus Museum of Art, Columbus, Ohio: Museum Purchase, Howald Fund. 1947.095

Early in his professional career, Bellows was rebuked by a finicky critic for placing an incorrectly painted "New York" cow in one of his landscapes. Over the years, he made a point of mastering the art of painting cattle, and it is hard to find fault with these particular bovines, although these were New York cows, painted near Woodstock.

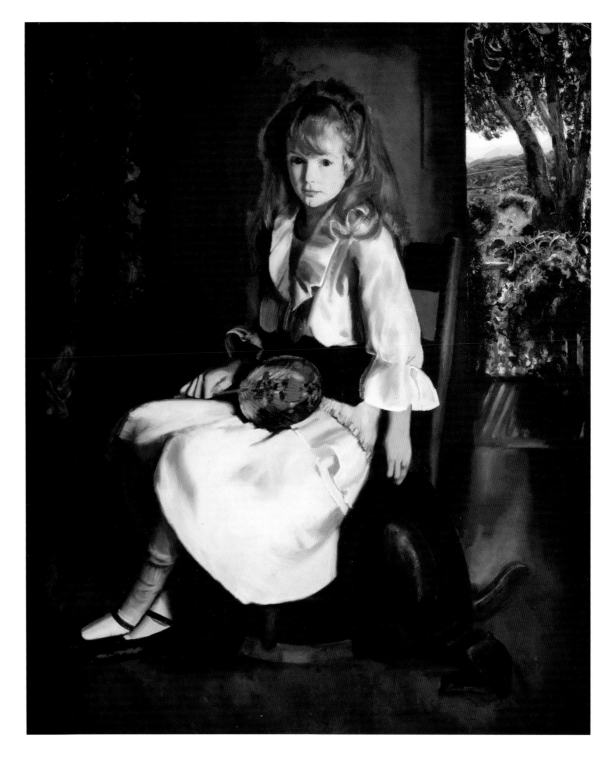

exhibitions at the Woodstock Art Association, outdoor pageants, theatrical entertainments, food, music, dancing, and general merriment. In 1921, the main event was a stage production of Gustave Flaubert's hallucinatory story *The Temptation of Saint Anthony*, for which the aptly surnamed George Bellows was cast in the narrator's role. Held on the night of a full moon, with an orchestra of musicians from the Metropolitan Opera House, it drew an overflow crowd of enthusiastic theatergoers from near and far.

Before returning to New York, George and Emma agreed that from now on all their summers would be spent in Woodstock, a place that suited them perfectly in almost every way.

133

Aunt Fanny (Old Lady in Black)
1920
Oil on canvas
44¹/₈ × 34¹/₄ in.
(112.1 × 87 cm)
Des Moines Art Center
permanent collections, Des
Moines, Iowa: Purchased with
funds from the Edmundson Art
Foundation, Inc. 1942.1
Photography: Michael Tropea,
Chicago

At Bellows's expense, Aunt
Fanny (by then Mrs. Henry
Daggett) came all the way from
San Diego, to spend the
summer of 1920 in Woodstock.
Posing in a fine old Windsor
chair, she looks toward the
artist with the same affection
she had shown him as a little
boy. A year later this portrait
won the First Harris Prize at the
Art Institute of Chicago and a
gold medal at the National Arts
Club in New York.

Elinor, Jean, and Anna
1920
Oil on canvas
66 × 73 in.
(167.6 × 185.4 cm)
Albright-Knox Art Gallery,
Buffalo, New York: Charles
Clifton Fund, 1923. 1923.32

This painting, yet another
triumph for Bellows, won
acclaim at the Carnegie
International in 1922. Its
composition was based on a
system called "Dynamic
Symmetry," devised by Jay
Hambidge. Bellows attended
his lectures in 1917, and soon
began to rely on Canadian-born
Hambidge's complex geometric-
ratio theories, particularly in
planning the composition of his
portraits. When his old friend
Professor Taylor expressed
admiration for this picture,
Bellows explained how it came
about, thanks to Hambidge's
methods.

After Bellows's death, Taylor
recounted the steps taken in
the construction of *Elinor,
Jean, and Anna* in the February
1925 issue of the *Ohio State
University Monthly*, as follows:

*A painting is finished,
Whistler used to say, when
all trace has disappeared of
the means that brought it
into being.*
 *The labor in this case was
sure and swift and successful
from the beginning, without
one experiment or wasted
motion: but labor all the
greater. Our friend must have
had the image ready, long
matured in his mind, but the
actual work began with his
models, the two old ladies and
the little girl, between them,
posed while he made a very
careful and detailed pencil-
drawing of them. Then he
attacked the big blank canvas
with a T-square and a triangle,
with an intense architectural
planning that fixed
mathematically the points of*

*focus and their relation to each
other; upon this plot of lines,
and of course to this greater
scale, he transferred his
pencilled pose, the faces and
the hands falling accurately
upon the right line-crossings
of his scheme. All this before
a touch of the brush, several
days of hard and concentrated
work. Then he painted the
background, the enveloping
dusk of the house-interior,
leaving the three figures
silhouetted in white canvas;
and then the costumes, calling
the wearers in turn for short
poses, leaving still blank the
hands and faces; and then the
hands, wonderful old hands,
and then the faces, wonderful
old faces, of his aunt on the left
and his mother on the right;
and last and hardest of all, his
little daughter in the middle.
With her portrait finished, and
without one other additional
touch or backward look, the
painting was all at once
simultaneously finished.
No wonder it looks so easy.*

Self-Portrait
1921
Lithograph
10½ x 7⅞ in.
(26.7 x 20 cm)
Columbus Museum of Art,
Columbus, Ohio: Museum
Purchase with funds provided
by Lois Chope. 2002.018.023

In his studio Bellows concocted
an intriguing riddle for the
viewer. Simultaneously, he was
studying himself in an
elaborately framed mirror and
drawing his image on the thick
lithograph stone before him.

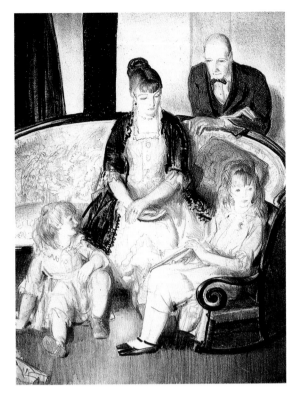

Sunday 1897
1921
Lithograph
12 × 15 in.
(30.5 × 38.1 cm)
Columbus Museum of Art,
Columbus, Ohio: Museum
Purchase, Mrs. H.B. Arnold
Memorial Fund. 1955.005

This is one of Bellows's
"memory pictures," harking
back to his Columbus days. His
father waves to a pedestrian,
identified as the Reverend
Purley A. Baker, as the family
proceeds to church in a horse-
drawn surrey. Adolescent
George is ignominiously pinned
between his father and another
passenger.

My Family (Second Stone)
1921
Lithograph
10⅛ × 8 in.
(25.7 × 20.3 cm)
Columbus Museum of Art,
Columbus, Ohio: Museum
Purchase with funds provided
by Lois Chope and Gift of Mrs.
William Neil King, by exchange.
2002.018.019

Jean, Emma, George, and Anne
enjoy a family moment together.
Bellows cared deeply for his
family and they were frequent
subjects of his art.

A Knockout
1921
Lithograph
15¼ × 21¾ in.
(38.7 × 55.3 cm)
Columbus Museum of Art,
Columbus, Ohio: Museum
Purchase with funds provided
by a gift from Mr. and Mrs.
Frederick Jones, by exchange.
2002.018.001

Returning to prizefighting
scenes, Bellows recreates the
mayhem both inside and
outside the ring that he
remembered from the old days
in the back room of Sharkey's
saloon.

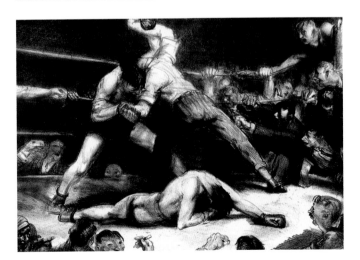

Emma Bellows, Eugene Speicher, Elsie Speicher, and George Bellows
Circa 1920
The Gaede/Striebel Archive, Center for Photography at Woodstock, permanent print collection, Woodstock, New York: On extended loan to the Samuel Dorsky Museum of Art, State University of New York at New Paltz

Sporting a false mustache and what appears to be a Victorian-era military uniform, George joined friends also in costume for one of Woodstock's famous summer theatricals.

Therefore, it made good economic sense to design and build a cottage of their own—something George had always wanted to do. There was some vacant land at the foot of Overlook Mountain, adjacent to the Speichers' house, so inquiries were made and negotiations begun. Elated, George measured off the lot and got out his drafting tools. He and Emma would spend the 1921–22 winter planning and replanning the ideal summer house.

On December 1, the Montross Gallery was scheduled to open a big new show, *Paintings and Drawings by George Bellows*, which also included forty lithographs. After a long last look at their very own tract of land, they hurried back to East Nineteenth Street, jubilant.

Jean in a Pink Dress
1921
Oil on canvas
32 × 26 in.
(81.3 × 66 cm)
Private collection
Courtesy of Debra Force Fine Art, Inc., New York, New York

Jean Bellows grew up to become an actress and comedienne with at least three Broadway productions and a great deal of summer stock behind her when marriage put an end to her stage career. In this portrait, her tears are genuine: as she posed, her mother read to her from a particularly tragic portion of *Black Beauty*. In October 1941, *Life* magazine ran an illustrated article, "Portraits of George Bellows's Daughter," mentioning that "Bellows himself discovered Jean first at the age of one. She seemed to have the ability to keep her feelings up on the front of her face, even as she grew older. She was always very merry or very wistful or very grave. She was so good that Bellows's great friends Eugene Speicher and John Carroll began to paint her, too."

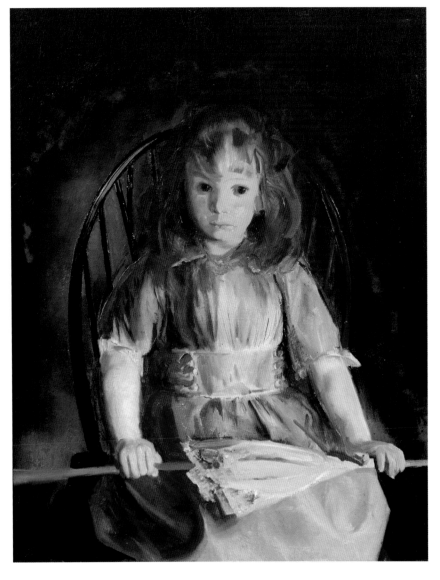

In a darkened setting
reminiscent of a parlor in his
childhood home, Bellows
painted his mother's portrait
twice during her visit to
Woodstock in 1921. She died
two years later at the age of
eighty-five.

The Architect

There are moments in our lives, moments in a day, when we seem to see beyond the usual, become clairvoyant. We reach then into reality. Such are the moments of our greatest happiness, of our greatest wisdom. At such times there is a song going on within us to which we listen. But few are capable of holding themselves in a state of listening to their own song. Intellectuality steps in, and as the song within us is of the utmost sensitiveness, it retires in the presence of the cold intellect . . . it is the desire to express these songs from within that motivates all masters of art.

Robert Henri, *The Art Spirit*, 1923

N early April, 1922, when the Bellows family returned to Woodstock, they found the foundations of their dream cottage already laid, thanks to a local contractor. While Emma, Jean, Anne, and George's mother entered into the life of the village and went shopping for hand-me-down furniture at country auctions and secondhand shops, George rose early and spent all day, every day, at the site, acting as both supervisor and head carpenter. Eugene Speicher lent a hand, too, and when the time came Bellows shingled the steep roof with the help of John Carroll. Carroll, a young painter from across the Hudson who had studied with Frank Duveneck, devised a novel roof-shingling technique for avoiding splinters and scratches: before mounting the ladders they stuffed the fronts of their clothes with pillows.

As it took shape, the little house emerged as modest, simple, and quite in keeping with its neighbors. There were four bedrooms up under the eaves—one for the girls, one for their parents, one for an office, and one for the maid. Downstairs, Bellows installed an impressive fireplace in the roomy living area and built cupboards and cabinets in all the crannies.

A nearby brook provided running water and also served as a bathtub after Bellows widened a portion of it and lined it with concrete. There was no central heating, either, since they would seldom need it while they were there. Fireplaces and woodstoves would suffice. There were still walls to paint (white), also cabinets (orange). There were fruit trees and lilacs to plant too, but George left some of these jobs for later, because he had neglected his art for nearly four months.

While the hammers were pounding and saws were singing, *Elinor, Jean, and Anna* won a gold medal, first class, at the Carnegie International—medal number twelve for his collection. Two of Bellows's Woodstock paintings, *Cornfield at Harvest* and *Little*

George Bellows Sitting in Kitchen
Circa 1922
Amherst College Archives and Special Collections, Amherst, Massachusetts: George Wesley Bellows Papers, Box 5, folder 7

Bellows, a superb craftsman and cabinetmaker, worked tirelessly to make his family's homes more comfortable and efficient.

The White Horse
1922
Oil on canvas
34¹/₈ × 44¹/₁₆ in.
(86.7 × 111.9 cm)
Worcester Art Museum,
Worcester, Massachusetts:
Museum purchase. 1929.109

In the sparsely populated
Catskill region, Bellows's
landscapes were almost all
devoid of human figures—a
departure from many of his
previous outdoor pictures, in
which someone was almost
always out and about. In the
Woodstock paintings, houses
and livestock were often the
only signs of human habitation.

Bridge were shown at the Society of Independent Artists. Nothing to be ashamed of, considering the big architectural project, but he had hoped to have something more to show for himself before the year was over.

As soon as his womenfolk were settled under his roof, Bellows took to the countryside and set up his easel. In October, he painted *Sunset, Shady Valley* and *Geese and Storm Sky*, as well as a number of old barns and farmyards, and in November the enigmatic *White Horse* (see p. 141). Many of these autumn scenes have a brooding, mystical quality, as if this corner of the world lay under some inscrutable spell. Perhaps Flaubert's hallucinations had something to do with it. For whatever reason, Bellows's mood seems to have undergone a change when he went exploring by himself in the Catskill landscape.

Bellows was aware of this, and puzzled by it. Early in November, he confided to Henri:

I have had a curious siege of c(h)romos, buckeyes, and rotters. Smug bad work. They look good outdoors but like hell when they come in. There are a few which escaped the blemish. We have had a great time, and great weather. Today the first rain for 3 weeks. All my work this summer or rather this fall seems quite different. It may be good and may be not. Darned if I know. I just paint and this is what happens.*

Between January and May 1923, Brown and Bellows worked hard at the printing press, producing some fifty-six images—including one that depicted their arch-rival, the printmaker Joseph Pennell, as an active volcano. It was

Mountain Orchard
1922
Oil on panel
20 × 24 in.
(50.8 × 61 cm)
Private collection
Courtesy of H.V. Allison & Co.,
Larchmont, New York

* "Buckeyes" was a derogatory allusion to worthless paintings made for department stores and the like. Sinclair Lewis used the word in *Main Street*, which Bellows undoubtedly read, to describe Mrs. Cass's Gopher Prairie parlor, "plastered with 'hand-painted' pictures, 'buckeye' pictures, of birch trees, newsboys, puppies, and church-steeples on Christmas Eve."

Billy Sunday
1917
Lithograph
8⅞ × 16¼ in.
(22.5 × 41.3 cm)
Columbus Museum of Art,
Columbus, Ohio: Gift of Friends
of Art. 1936.002

Although Billy Sunday had
played in baseball's major
leagues for several years,
Bellows was still no fan of his.
In 1917, *The Masses* had
published a similar Bellows
illustration, accompanied by
some bitterly critical words
from the poet Carl Sandburg,
deemed so controversial that
Post Office officials held up the
March issue for two days. A few
months later, reviewing an
exhibition of Bellows's
lithographs, the *New York
Times* critic noted that "the
hysteria of revival crowds is
depicted with a detachment
that puts the frenzied gestures
of the revivalist in their place
as machinery of hypnotism, and
cleverly interprets the barbaric
quality of the whole scene."

used as a place card at a banquet for the New
Society of Artists in January.

A month later, Bellows's childhood friend
and neighbor Harriet Rhoads Kirkpatrick
organized a one-man exhibition of Bellows
lithographs in Columbus and asked him to give
an informal talk. There was a good crowd—
among them Bellows's English professor
Joseph R. Taylor. During the question and
answer period, Taylor rose and blandly asked:
"What other good lithographers are there in
America?" With a perfectly straight face,
Bellows appeared to ponder a moment,
then answered: "There aren't any."

In February and March, the Carnegie
Institute's department of fine arts put on a
one-man show, *Paintings, Drawings, and
Lithographs by George Wesley Bellows*, and on
April 6 both Bellows and Eugene Speicher were
in Pittsburgh as jurors in charge of choosing the
US prizewinners in the Twenty-second Carnegie
International Exhibition. In the same pro bono
spirit, Bellows donated some canvases to a May
street fair benefit sponsored by the New York
Association for the Aid of Crippled Children; a
few days later he exhibited one of his portraits,

Waldo Pierce, in a group exhibition, part of a
charity bazaar held by the radical Rand School
Students' League. Then it was time to go back
to Woodstock.

There, Bellows picked up where he left off,
finished the interior painting, planted the trees
and shrubs, and brought in the firewood: all the
things people do to get a cottage ready for
summer. In the studio, he worked on *Emma
and Her Children*, measuring 59 by 65 inches,
and on finishing a three-year-old project, *Emma
in the Purple Dress*.

For the first time in years, George's mother
was not a member of the house party. Much as
she loved being part of the group, she did not
feel up to it this year, and when Monett wired
George advising him to return to Columbus, he
wasted no time getting to Anna's side. She died
on August 21, 1923, at the age of eighty-five.

It was September when George returned to
his family. But before he was fully recovered, he
had to leave again, to record the now-legendary
September 14 Dempsey–Firpo fight for the
New York Evening Journal. This was the bout
in which Luis Angel Firpo of Argentina, the
"Wild Bull of the Pampas," knocked Dempsey

143

clear out of the ring and into the laps of the press corps. Bellows had a front-row seat and saw it all. He also watched as Dempsey turned into a Wild Bull himself and knocked down his opponent nine times. After two rounds, Dempsey was still the world champion.

Unfortunately, Bellows's firsthand graphics never appeared in the *Evening Journal* because of a wildcat strike by the pressmen's union. Instead, a year later he made two exciting lithographs of the event—*Dempsey and Firpo* and *Dempsey through the Ropes*—and also a large canvas of the same view.

Preoccupied with recent events and glumly mourning the loss of his mother, he put the finishing touches to *Emma and Her Children*, and began a tableau, measuring 59 by 65 inches, called *The Crucifixion*, the opposite of anything he had ever done before. It may have been intended as a memorial to his churchgoing mother. But when he displayed it a few months later at the New Society of Artists, it baffled many of the critics, including Henry McBride, who wrote in the *New York Herald*: "As it is he cannot detach himself enough from the masters to be one himself. At the reception the ominous word 'Goya' was continually rising above the choruses of praise, but to me there was far more Greco than Goya in the picture." McBride, it should be said, made a specialty of pointing out flaws in Bellows's work. This was not the first time, but it may have been the last. After the artist's untimely death, he had nothing but praise for George Bellows.

The busy 1923–24 exhibition season began for George on November 1, when the Art Institute of Chicago awarded Bellows the lucrative Logan Purchase Prize for *My Mother No. 2*. In Washington a few weeks later, *Emma and Her Children* received the First William A. Clark Prize and a gold medal at the Corcoran Gallery's *Ninth Biennial Exhibition of American Oil Paintings*.

Perhaps the high point of the season for Bellows, however, was the publication by Lippincott of Robert Henri's *The Art Spirit*, a delightful and inspiring collection of The Boss's classroom pronouncements. Margery Austen Ryerson assembled and edited it from notes she took while studying at the Art Students League and from lecture notes he supplied her.

Ryerson left no stone unturned in her choice selection of vintage Henri-isms, quoting his remarks on every imaginable subject, no matter how relevant, or irrelevant, to classroom matters. Bellows was pleasantly surprised when asked by *Arts and Decoration* magazine to review the book in its December 1923 issue. Henri knew such a book was in progress, having collaborated to some extent, but Bellows saw the early proofs first. Unable to contain his enthusiasm, he summoned The Boss to come and see something that might interest him. When Henri arrived, somewhat out of breath, Bellows sat him down and started to read to him. Abandoning all his plans for the evening, Henri stayed until long past midnight, when the marathon recitation finally ended. The book is still in print, and justifiably so.

Bellows's review began this way: "Robert Henri is properly 'my father.' I was brought up on the philosophy now made available in this rare book of his, *The Art Spirit*. Possibly I have never lived up to it, but I have believed in it. Henri's is a very personal angle on things, but in most of the arguments he sets forth in *The Art Spirit*, I vote yes, and point out that his is a book to be very carefully noted."

Twilight

*When all is said, the genius of George Bellows resides in this:
his power to invoke on canvas a world stirring with a
mysterious energy. The life that palpitates in the pigment
stings us into a startling awareness of itself. It is as though
we were observing life with an entirely new set of faculties
and participating in some magical process of creation.*

Editorial, *The Nation*, January 21, 1925

AGAIN, Bellows devoted the short, gray days of winter chiefly to lithography, and, by March 1924, he and Bolton Brown had published more than thirty images, many of them adaptations in black and white of earlier canvases. The Frank K.M. Rehn Gallery exhibited some of them in a one-man show, beginning on January 28. Simultaneously, his friend Marie Sterner opened her gallery for a display of fifty *Recent Lithographs by George Bellows*.

In April, as the daffodils in Gramercy Park were blooming, Bellows took up his brushes and painted a new version of *River Front* and a mesmerizing Woodstock fantasy called *The Picnic*. Here, figures of Emma, the girls, Eugene Speicher, and himself are scattered about in a rugged landscape, isolated from one another in a seemingly endless mirage of hills, sky, rocks, and water. Almost metaphysical in tone, it may have been meant as a meditation

My House, Woodstock
1924
Oil on panel
17³⁄₄ × 22 in.
(45.1 × 55.9 cm)
The Honorable Marilyn Logsdon Mennello and Michael Mennello Courtesy of Carol Irish Fine Art, New York, New York

Painted at the height of the 1924 autumn foliage display, Bellows's new house looked as if it had been standing in Woodstock for generations. He wrote to Henri that "the house, studio, grounds, swimming pool are all a great success and I exhibit them like a fine picture."

Lady Jean
1924
Oil on canvas
72 × 36 in.
(182.9 × 91.4 cm)
Yale University Art Gallery, New
Haven, Connecticut: Bequest of
Stephen Carlton Clark, B.A.
1903. 1961.18.7

Lady Jean

147

***Mr. and Mrs. Phillip
Wase***
1924
Oil on canvas
51¹/₄ × 63 in.
(130.2 × 160 cm)
Smithsonian American Art
Museum, Washington, D.C.:
Gift of Paul Mellon
Photography: Smithsonian
American Art Museum,
Washington, D.C./Art Resource,
New York

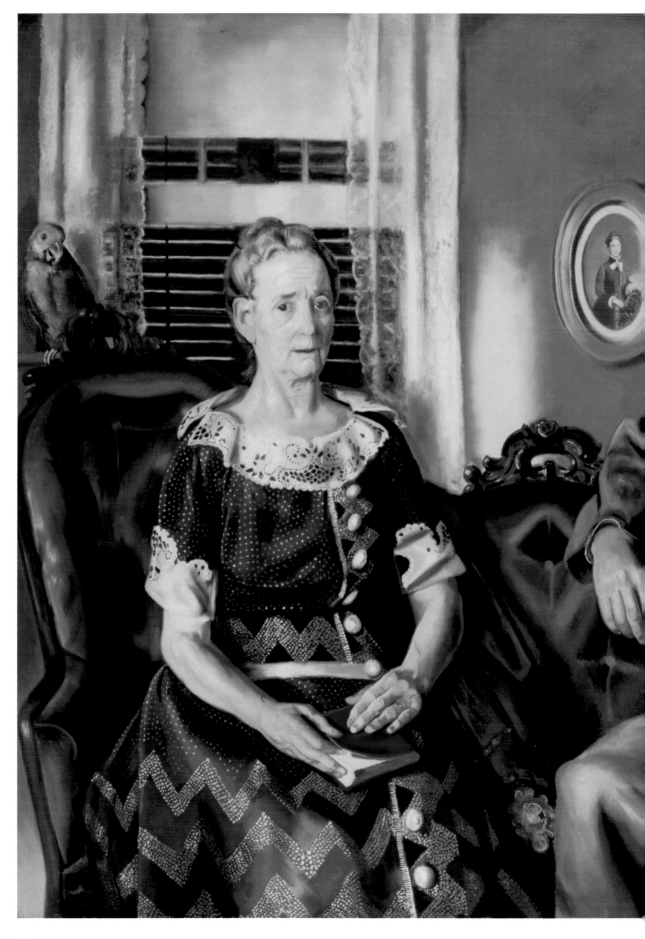

on mankind's insignificance in the presence of nature.

Back in the Catskills for the summer, Bellows made fewer forays beyond his own neighborhood than on previous visits. He painted a colorful "house portrait" of his new summer retreat and one or two others in the village of Woodstock, preferring evidently to do more studio work this year. Models of all ages came to pose, and he made some wonderful costume pictures of family members, including a splendid one of his nine-year-old daughter, *Lady Jean* (see p. 147), posing in the dress of an 1870s Southern Belle.

If anyone noticed that Bellows was not quite his usual vigorous self that summer, he would have dismissed it as just a little bellyache. But eventually, in August, he went to see Dr. Downer, the village physician, about some stomach trouble, and learned that his appendix seemed to be dangerously inflamed: Bellows should consult a specialist when he returned to New York. The pain came and went in an erratic fashion, so he simply shrugged it off and even joked about the inconvenience.

During the autumn, he felt somewhat better and persuaded some Woodstock neighbors, a couple named Wase, to sit for a double portrait. In such compositions, Bellows often painted his subjects separately, concentrating on one at a time. That seems to have been the case with *Mr. and Mrs. Phillip Wase*, who appear to be in separate worlds—he thinking faraway thoughts and she painfully aware of her surroundings and wishing she were anywhere else. She does not seem aware that her husband is close by to protect her, and maybe he was not.

The Bellowses were back in New York by Thanksgiving, and he managed to conceal his illness from others through Christmas and even through the Henris' New Year's Eve costume gala, where, dressed as Queen Victoria, he was the life of the party. On New Year's Day, he

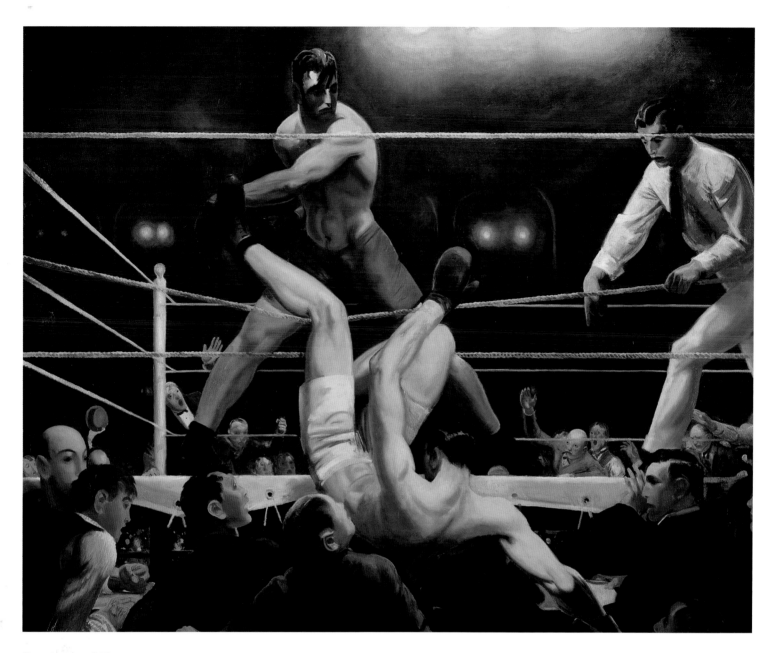

Dempsey and Firpo
1924
Oil on canvas
51 × 63¼ in.
(129.5 × 160.7 cm)
Whitney Museum of American
Art, New York: Purchase, with
funds from Gertrude Vanderbilt
Whitney. 31.95

The last of Bellows's boxing
pictures and his third and final
rendition of this particular bout,
this big new canvas disappointed
some art critics. On the other
hand, Archie Moore, himself the
light-heavyweight champion in
the 1950s and early 1960s,
thought very highly of this
painting. "You know," he said,
"you call this art. I call it a
helluva punch."

refused all food, but the following morning he
decided to move ahead, no matter what, with
a long-delayed project, the reflooring of his
upstairs studio. Suddenly, involuntarily, he
cried out to Emma, who found him doubled
over with pain and called an ambulance.

At Columbia's Postdoctoral Hospital
Bellows's ruptured appendix was safely
removed. But it was too late: peritonitis had
already poisoned his system. He lingered on
in the hospital, semi-delirious, until the early
hours of Thursday, January 8, 1925. Then

Bellows, the big, strong, hearty, sturdy,
dauntless, indefatigable George Bellows,
was gone at the age of forty-two.

On his easel at home lay the nearly finished
Picket Fence, and on his calendar there was
an important date: February 1, 1925—a solo
exhibition at the prestigious Durand-Ruel
Galleries. Eugene Speicher completed the
painting, and with Emma's blessing, the
exhibition opened on schedule: *Last Canvases
by George Bellows*.

On the Death of George Bellows

by Joseph Russell Taylor, Class of 1887: *The Ohio State University Monthly,*
February 1925

AS we crossed town to reach the house, coming through what has always seemed to me the most homelike neighborhood in New York, we came through picture after picture of his making, George Bellows. The little park, Gramercy, was white with snow, and no one was there; but we saw there old sunlight shafting through green leafage now fallen and refallen, and in the middle Jean or Anne playing as if she should never be old. Mr. Henri's house faces the park, and the Players, and the National Arts Club; our friend's most familiar haunts, and now, as it seemed to us in our moment of passing, crowded like a sudden festival, a summoning together from near and far, with memories of him. We spoke as we passed of one of these, and I know of no better way to express this whole experience than to stop for it, as we did not stop, on our way to the house round the corner.

He himself told it to me with his big laughter. It happened at the National Arts Club. Mr. Joseph Pennell discoursed to the members on the art of lithography, and there was afterward a free discussion; they got rather away from the subject, but so much the better, for the discussion developed into an excellent little controversy between our friend and the speaker. The point at issue was by now Mr. Pennell's dictum that no artist could paint or draw beyond the thing which he himself saw with his own eyes; true enough in essence; all art is necessarily thus at first hand, as we say, the artist's own personal experience; but Mr. Pennell denied that the artist could ever with any safety see and experience beyond the actual fact before him. We all know him, Mr. Pennell, and the good works he had done, no man better within the set limits of his practice. We know of him, also, and with no loss of appreciation, that he fights with a club. "If Mr. George Bellows," he said on this occasion, "had been himself present at the execution of Edith Cavell, and had seen the whole thing with his own eyes, he would have painted a far more authentic picture than the one he made up out of his head." This gave our friend his chance, too good a chance to bungle; when he rose to reply he approached casually and with much leisure Mr. Pennell's charge; then he answered it very suddenly. "No, I was not present at the murder of Edith Cavell," George Bellows said: "neither, so far as I have been able to learn, was Leonardo present at the Last Supper."

That big laughter of his was in our ears as we stopped at the house, round the corner, in Nineteenth Street. And they welcomed us there very simply: Mrs. Bellows, the Emma of the pictures and of our hearts, and the two young girls: they themselves will of course go on very proudly, they will live their own good lives, but like George himself now they will never grow old. Not that part of them that is in the pictures, no. The piano was silent, upstairs in the big studio, but she will always be there, one hand to the keyboard, looking over her shoulder at us. Emma, just before or just after the music. That's one of the good paintings, and I found myself thinking then and there of the good little story that goes with it. It was shown in one of the exhibitions, with a price duly appended in the catalogue, fifteen-hundred dollars; as the exhibition neared its last days our friend in his studio was called to the telephone to hear, in the voice of one of the well-known dealers, that Mr. Adolf Lewisohn offered one thousand dollars for it. "Nothing doing," said our friend: "I don't want to sell: I want to live for a while with that picture and maybe do some more things to it." Five minutes later the telephone rang again and informed him that the picture was sold at his own price. And I can see it as if I had been there, how George clashed the receiver back into place: "Doggone it," he cried, "I didn't want to sell that picture! Nohow!"

Death out of Ambush

Now we were talking together, very quietly, of this sudden and incredible thing, George's death. In these days the operation for appendicitis is classed as minor, and the doctors themselves thought he would be in hospital for little more than a week; maybe because to them, too, as to the rest of us, he was so big and strong and full of life; but after the second day, he sank so swiftly that the first word Mrs. Bellows could send out, to the family and the friends, none of whom even knew that he was sick, was the fact of his death. Yet over and over again it was this present fact that seemed unreal, some old unhappy far-off thing; and the whole house, full of his paintings, seemed no less full of his presence. We all knew, and took as a matter of course, how hard he worked; I do not speak so much of the great quantity of his production, although few men in the whole history of art have achieved at forty-two so much and so varied great work: I mean the intense and prolonged concentration, the reckless spiritual expense, that he gave in the making of these pictures each as it came. Big and athletic as he was, he was often a wreck at the end of a day's painting. But there is no true reason why he should not have lived out his normal life, and painted those yet greater pictures we all confidently looked for. His death was a leap out of ambush. And yet, as I keep repeating, I could not keep his death surely in my mind, I thought in that house of pictures rather of them and their making, as of things still to talk over with him.

The Funeral

I am talking too much for what means to be no more than a record of our farewell to George Bellows. The funeral services were held in the early afternoon, in the Church of the Ascension. Led by his closest intimates, Robert Henri and Eugene Speicher, there were twenty-four of us his friends who were "pallbearers," all artists, many of them famous, but most of all friends; I think no man had more, I think the whole churchful were intimates. And I know one thing at least was common to all of us, and to his family across the aisle: that the George who so hated pose and pretense, George there buried in the massed flowers, would have found no fault with the simple ritual, the immemorial poetry that with the music constituted the whole service; nor with the choir—I don't know what the anthem was, very brilliant music but somebody said it was a negro spiritual orchestrated into the quartet, something that George had long liked; all in that beautiful church with our eyes on LaFarge's great painting of the Ascension and the St. Gaudens Angels beneath it. Then they took him to Greenwood and we came away.

Bibliography

Adams, Clinton, *American Lithographs, 1900–1960: The Artists and Their Printers*, Albuquerque (University of New Mexico Press), 1983

Alumni Association of the Columbus High School and Central High School, Inc., *History Columbus High School, 1847–1910*, Columbus (Spahr and Glenn) 1925

"Americanism of George Bellows," *Literary Digest* 87, January 31, 1925, pp. 26–27

The American Century: Art and Culture, 1900–2000. Part 1, 1900–1950, exhib. cat. by Barbara Haskell, New York, Whitney Museum of American Art and W.W. Norton & Co., April–August 1999

American Realism and the Industrial Age, exhib. cat. by Marianne Doezema, Cleveland, Cleveland Museum of Art, 1980

An American Pulse: The Lithographs of George Wesley Bellows, exhib. cat. by D. Scott Atkinson and Charles S. Engel, San Diego, San Diego Museum of Art, 1999

Anderson, Sherwood, "An Estimate of Appreciation of an Authentic American Portrait," *Vanity Fair* 25, November 1925, pp. 57, 94

Ashcan Kids: Children in the Art of Henri, Luks, Glackens, Bellows and Sloan, exhib. cat. by Bruce Weber, New York, Berry-Hill Galleries, Inc., December 1998 – January 1999

Beck, Henry Charlton, *The Jersey Midlands*, New Brunswick, New Jersey (Rutgers University Press) 1984

Bellows, Emma S., *George W. Bellows: His Lithographs*, New York (Alfred A. Knopf) 1927

Bellows, Emma S., *The Paintings of George Bellows*, New York (Alfred A. Knopf), 1929

"Bellows' Estate," *Art Digest* 1, January 1, 1927, p. 11

"Bellows in Chicago," *Arts and Decoration* 12, November 1919, p. 10

"Bellows' Life and Works—Main Facts of His Career," *Ohio State University Monthly* 16, February 1925, pp. 9–10

Bellows, George, "An Ideal Art Exhibition," *American Art News* 12, December 26, 1914, p. 2 [letter to the editor]

Bellows, George, "The Art Spirit by Robert Henri," *Arts & Decoration* 20, December 1923, pp. 26, 87

Bellows, George, "The Big Idea: George Bellows Talks about Patriotism for Beauty," *Touchstone* 1, July 1917, pp. 269–75

Bellows, George, "The Relation of Art to Every-day Things; An Interview with George Bellows," interview by Estelle Reis, *Arts and Decoration* 15, July 1921, pp. 158–60, 202–203

Bellows, George, "The Relation of Painting to Architecture: An Interview with George Bellows," *American Architect* 118, December 29, 1920, pp. 847–51

Beuf, Carlo, "The Art of George Bellows: The Lyric Expression of the American Soul," *The Century Magazine* 112, October 1926, pp. 724–29

Boswell, Peyton, Jr., *George Bellows*, New York (Crown Publishers) 1942

Braider, Donald, *George Bellows and the Ashcan School of Painting*, Garden City, New York (Doubleday & Co.) 1971

Brooks, Van Wyck, *America's Coming of Age*, New York (E.P. Dutton) 1915

Brown, Milton W., *American Painting from the Armory Show to the Depression*, Princeton, New Jersey (Princeton University Press) 1955

Brown, Rollo Walter, "George Bellows—American," *Scribner's Magazine*, May 1928, pp. 574–87

Buchanan, Charles L., "George Bellows, painter of Democracy," *Arts and Decoration* 4, August 1914, pp. 370–73

Clark, Edna Maria, *Ohio Art and Artists*, Richmond (Garrett and Massie) 1932

Clark, Eliot, *History of the National Academy of Design 1825–1953*, New York (Columbia University Press) 1954

College Art Association of America, "George Wesley Bellows—Painter and Graver," *The Index of Twentieth-Century Artists* 1, March 1934, pp. 81–94

Cornell, Fred A., "The Tribute of a Friend from Boyhood," *Ohio State University Monthly* 16, February 1925, p. 9

Cortissoz, Royal, *American Artists*, New York (Charles Scribner's Sons) 1923

Craven, Thomas, "George Bellows," *Dial* 80, February 1926, pp. 133–36

Crowninshield, Frank, "An Appreciation of the Life and Work of George Bellows," *Art News* 23, January 17, 1929, p. 6

Dell, Floyd, *Homecoming: An Autobiography*, New York (Farrar & Rinehart) 1933

Deutsch, Babette, "A Superb Ironist," *New Republic* 23, July 21, 1920, pp. 220–21

Doezema, Marianne, *George Bellows and Urban America*, New Haven (Yale University Press) 1992

Du Bois, Guy Pène, *Artists Say the Silliest Things*, New York (American Artists Group, Inc., Duell, Sloan, and Pearce) 1940

Eastman, Max, *Enjoyment of Living*, New York (Harper & Bros.) 1948

Eggers, George W., *George Bellows*, New York (Whitney Museum of American Art) 1931

Ely, Catherine Beach, "The Modern Tendency in Henri, Sloan and Bellows," *Art in America* 10, April 1922, pp. 132–43

Evers, Alf, *Woodstock: History of an American Town*,

Woodstock, New York (Overlook Press) 1987

Falk, Peter Hastings, and Andrea Ansell Bien, *The Annual Exhibition Record of the National Academy of Design, 1901–1950,* Madison, Connecticut (Sound View Press) 1990

The Fiftieth Anniversary of the Exhibition of Independent Artists in 1910, exhib. cat., Wilmington, Delaware, Delaware Art Center, January–February 1960

Fishbein, Leslie, *Rebels in Bohemia: The Radicals of "The Masses," 1911–1917,* Chapel Hill (University of North Carolina Press) 1982

Fitzgerald, Richard, *Art and Politics: Cartoonists of "The Masses" and "Liberator,"* Westport, Connecticut (Greenwood Press) 1973

Flint, Ralph, "Bellows and His Art," *International Studio* 81, May 1925, pp. 79–88

Frohman, Louis H., "Bellows as an Illustrator," *International Studio,* February 1924, pp. 421–25

George Bellows and the War Series of 1918, exhib. cat., New York, Hirschl & Adler Galleries Inc., April 1983

George Bellows: A Retrospective Exhibition, exhib. cat., intro. by Henry McBride, Washington, D.C., National Gallery of Art, January–February 1957

George Bellows: Love of Winter, exhib. cat. by David Setford and John Wilmerding, West Palm Beach, Florida, The Norton Museum of Art, December 1997 – January 1998

George Bellows: Paintings, Drawings, and Prints, exhib. cat. by Frederick A. Sweet, Carl O. Schniewind, and Eugene Speicher, Chicago, The Art Institute of Chicago, January–March 1946

George Bellows: The Artist and His Lithographs, 1916–1924, exhib. cat. by Jane Myers and Linda Ayres, Fort Worth, Amon Carter Museum, September–November 1988

"George Bellows," *The Nation* 120, January 21, 1925, p. 60

George Bellows: Works from the Permanent Collection of the Albright-Knox Art Gallery, exhib. cat. by Catherine Green, Buffalo, Albright-Knox Art Gallery, August–September 1981

George Wesley Bellows: Paintings, Drawings, and Prints, exhib. cat. by Lee Malone *et al.*, Columbus Museum of Art, Ohio, 1979

Goldman, Emma, *Living My Life,* 2 vols., New York (Alfred A. Knopf) 1931

Gutman, Walter, "George Bellows," *Art in America* 17, February 1929, pp. 103–12

Hahn, Emily, *Romantic Rebels: An Informal History of Bohemianism in America,* Boston (Houghton-Mifflin) 1967

Hambidge, Jay, *Dynamic Symmetry in Composition as Used by the Artists,* Cambridge, Massachusetts (privately printed) 1922

Hapgood, Hutchins, *Types from City Streets,* New York (Garrett Press, Inc.) 1970

Hapgood, Hutchins, *A Victorian in the Modern World,* Seattle (University of Washington Press) 1939

Haverstock, Nathan A., *Fifty Years at the Front,* Washington and London (Brassey's) 1996

Henri, Robert, *The Art Spirit,* compiled by Margery Austen Ryerson, Philadelphia (J.B. Lippincott) 1923

Henri, Robert, "The New York Exhibition of Independent Artists," *The Craftsman* 18, 1910, pp. 160–72

Hicks, Granville, *John Reed: The Making of a Revolutionary,* New York (Macmillan) 1937

Homer, William Innes, *Robert Henri and His Circle*, Ithaca and London (Cornell University Press) 1969

Hooper, Osman Castle, *History of Columbus, Ohio,* Columbus (Memorial Publishing Co.) 1920

Hopkins, James Roy, "The Tribute of a Fellow Artist," *Ohio State University Monthly* 16, February 1925, p. 6

"The Hun: Lithographs by George Bellows," *Vanity Fair,* November 1918, pp. 36–37

Huneker, James Gibbons, *Americans in the Arts, 1890–1920,* New York (AMS Press) 1985

Huneker, James Gibbons, "What is the Matter with the National Academy?" *Harper's Weekly* 56, April 6, 1912, p. 8

Kelly, Jean P., "G.B. Our Own," *Ohio State Alumni Magazine* 84, December 1992, pp. 11–14.

Kent, Rockwell, *It's Me O Lord: The Autobiography of Rockwell Kent,* New York (Dodd, Mead & Co.) 1955

Keny, James M., Nannette V. Maciejunes, and David A. Simmons, "The World of George Bellows," *Timeline* (October–December 1992) [special issue published by the Ohio Historical Society]

Lankevich, George J., *American Metropolis: A History of New York City,* New York (New York University Press) 1998

Larkin, Oliver W., *Art and Life in America,* New York (Rinehart & Co.) 1949

Leaving for the Country: George Bellows at Woodstock, exhib. cat. by Marjorie B. Searl and Ronald Netsky, New York, Chicago, andf Georgia, 2003–2004

London, Jack, *War of the Classes,* New York (Macmillan) 1905

Marlor, Clark S., *The Society of Independent Artists: The Exhibition Record, 1917–1914,* Park Ridge, New Jersey (Noyes Press) 1984

Mason, Lauris, and Joan Ludman, *The Lithographs of George Bellows: A Catalogue Raisonné,* Millwood, New York (Kto Press) 1977

Mather, Frank Jewett, Jr., *Eugene Speicher,* New York (Whitney Museum of American Art) 1931

May, Henry F., *The End of American Innocence: A Study of the First Years of Our Own Time, 1912–1917,* New York (Alfred A. Knopf) 1959

McBride, Henry, *The Flow of Art: Essays and Criticisms,* repr. New Haven (Yale University Press) 1997

McBride, Henry, "Bellows and His Critics," *The Arts* 8, November 1925, pp. 291–95

Memorial Exhibition of the Works of George Bellows, exhib. cat., intro. by Frank Crownshield, New York, Metropolitan Museum of Art, 1925

Moore, Opha, *History of Franklin County, Ohio,* Topeka (Historical Publishing Co.) 1930

Morgan, Charles H., *The Drawings of George Bellows,* Alhambra, California (Border Publishing Co.) 1973

Morgan, Charles H., *George Bellows: Painter of America,* New York (Reynal & Co.) 1965

Newman, Sarah, "George Bellows' New York and the Spectacular Reality of the City," *American Art* 18, Fall 2004, pp. 92–98

Next to Nature: Landscape Paintings from the National Academy of Design, exhib. cat., ed. by Barbara Novak and Annette Blaugrund, New York, The National Academy of Design, 1980

Oates, Joyce Carol, *George Bellows: American Artist,* Hopewell, New Jersey (Ecco Press) 1995

O'Neill, William L. (ed.), *Echoes of Revolt: "The Masses," 1911–1917,* Chicago (Quadrangle Press) 1966

Painters of a New Century: The Eight and American Art, exhib. cat. by Elizabeth Milroy, Milwaukee, Milwaukee Art Museum, 1991

Paterson, Robert G., "'Ho' Bellows on Campus and the Teams," *Ohio State University Monthly* 16, February 1925, pp. 7–8

Pennell, Joseph, *Adventures of an Illustrator*, Boston (Little, Brown) 1925

Perlman, Bennard B., *Painters of the Ashcan School: The Immortal Eight,* New York (Dover Publications) 1979

Petruck, Peninah R.Y., *American Art Criticism, 1910–1939,* New York (Garland Publishing) 1981

Phillips, Duncan, "The Allied War Salon," *American Magazine of Art* 10, February 1919, pp. 115–23

Portraits by George Bellows, exhib. cat. by Margaret C.S. Christman, Washington, D.C., National Portrait Gallery, November 1981 – January 1982

Pousette-Dart, Nathaniel, *Robert Henri*, New York (Frederick A. Stokes) 1922

Quick, Michael, Jane Myers, Marianne Doezema, and Franklin Kelly, *The Paintings of George Bellows*, New York (Harry N. Abrams, Inc.) 1992

Rich, Daniel Catton, "Bellows Revalued," *Magazine of Art*, April 1946, pp. 139–42

Rich, Daniel Catton (ed.), *The Flow of Art: Essays and Criticism of Henry McBride*, New Haven (Yale University Press) 1975

Rihani, Ameen, "Luks and Bellows: American Painting, Part III," *International Studio*, August 1920, pp. xxi–xxvii

Robert Henri and Five of His Pupils: George Bellows, Eugene Speicher, Guy Pène du Bois, Rockwell Kent, Edward Hopper, exhib. cat. by Helen Appleton Read, New York, April–June 1946; repr. Freeport, New York (Books for Libraries Press) 1971

Roberts, Mary Fanton, "George Bellows—An Appreciation," *Arts and Decoration* 23, October 1925, pp. 38–40, 76

Romantic Painting in America, exhib. cat. by James Thrall Soby and Dorothy C. Miller, New York, Museum of Modern Art, November 1943 – February 1944

Savage, James, *A Genealogical Dictionary of the First Settlers of New England* 1, Boston (Little, Brown) 1860

Schiff, Bennett, "The Boy Who Chose the Brush over Baseball," *Smithsonian* 23/3, June 1992, pp. 59–70

Seiberling, Frank, Jr., "George Bellows, 1882–1925: His Life and Development as an Artist," diss., Chicago, University of Chicago, 1948

Sessions, Francis C., "Art and Artists in Ohio," *Magazine of Western History* 4, August 1886, pp. 485–88

Sharp Young, Mahonri, *The Paintings of George Bellows*, New York (Watson-Guptill), 1973

Sloan, John, *John Sloan's New York Scene from the Diaries, Notes, and Correspondence, 1906–1913,* ed. Bruce St. John, intro. by Helen Farr Sloan, New York (Harper & Row) 1965

Smith, Daniel M., *The Great Departure: The United States and World War I, 1914–1920,* New York (John Wiley and Sons) 1965

Sullivan, Mark, *Our Times: The United States 1900–1925*, vols. 4 and 5, New York (Charles Scribner's Sons) 1932

Swift, Samuel, "Down with the Art Jury!" *Harper's Weekly* 56, February 10, 1912, pp. 13–14

Taff, Mark L., and Lauren R. Boglioli, "Fraternity Hazing Revisited through a Drawing by George Bellows," *JAMA: Journal of the American Medical Association* 269, April 28, 1993, pp. 2113–15

Tatham, David, (ed.), *Prints and Printmakers of New York State, 1825–1900,* Syracuse, New York (Syracuse University Press) 1986

Taylor, Joseph Russell, *Composition in Narration,* New York (Henry Holt) 1910

Taylor, Joseph Russell, "On the Death of George Bellows," *Ohio State University Monthly* 16, February 1925, pp. 3–6

Thurber, James, *The Thurber Album: A Collection of Pieces about People,* New York (Simon & Schuster) 1952

Tufts, Eleanor, "Realism Revisited: Goya's Impact on George Bellows and Other American Responses to the Spanish Presence in Art," *Arts Magazine* 57, February 1983, pp. 105–12

Watson, Forbes, "George Bellows," *The Arts* 7, January 1925, n.p.

Weitenkampf, Frank, *American Graphic Art,* New York (Henry Holt) 1912

Wertheim, Arthur Frank, *The New York Little Renaissance: Iconoclasm, Modernism, and Nationalism in American Culture, 1908–1917,* New York (New York University Press) 1976

White, William Allen, "The Insurgence of Insurgency," *American Magazine* 71, December 1910, pp. 170–74

Wilmerding, John, *American Views: Essays on American Art,* Princeton (Princeton University Press) 1991

Wilson, Edmund, "George Bellows," *New Republic* 44, October 28, 1925, pp. 254–55

Young, Art, *Art Young: His Life and Times,* New York (Sheridan House) 1939

Young, Art, *On My Way: Being the Book of Art Young in Text and Picture,* New York (Horace Liveright) 1928

Zurier, Rebecca, *Art for "The Masses,"* Philadelphia (Temple University Press) 1988

Zurier, Rebecca, Robert W. Snyder, and Virginia Mecklenberg, *Metropolitan Lives: The Ashcan Artists and Their New York,* New York (W.W. Norton) 1995

Index